An Analysis of

Erwin Panofsky's

Meaning in the Visual Arts

Emmanouil Kalkanis

Published by Macat International Ltd
24:13 Coda Centre, 189 Munster Road, London SW6 6AW.

Distributed exclusively by Routledge
2 Park Square, Milton Park, Abingdon, Oxon OX14 4RN
711 Third Avenue, New York, NY 10017, USA

Routledge is an imprint of the Taylor & Francis Group, an informa business

www.macat.com
info@macat.com

Cataloguing in Publication Data
A catalogue record for this book is available from the British Library.
Library of Congress Cataloguing-in-Publication Data is available upon request.
Cover illustration: Jonathan Edwards

ISBN 978-1-912453-92-4 (hardback)
ISBN 978-1-912453-89-4 (paperback)
ISBN 978-1-912453-90-0 (e-book)

CONTENTS

WAYS IN TO THE TEXT

Who Was Erwin Panofsky? 9

What Does *Meaning in the Visual Arts* Say? 11

Why Does *Meaning in the Visual Arts* Matter? 12

SECTION 1: INFLUENCES

Module 1: The Author and the Historical Context 16

Module 2: Academic Context 21

Module 3: The Problem 26

Module 4: The Author's Contribution 31

SECTION 2: IDEAS

Module 5: Main Ideas 37

Module 6: Secondary Ideas 42

Module 7: Achievement 48

Module 8: Place in the Author's Work 53

SECTION 3: IMPACT

Module 9: The First Responses 59

Module 10: The Evolving Debate 64

Module 11: Impact and Influence Today 71

Module 12: Where Next? 77

Glossary of Terms 83

People Mentioned in the Text 91

Works Cited 102

THE MACAT LIBRARY

The Macat Library is a series of unique academic explorations of seminal works in the humanities and social sciences – books and papers that have had a significant and widely recognised impact on their disciplines. It has been created to serve as much more than just a summary of what lies between the covers of a great book. It illuminates and explores the influences on, ideas of, and impact of that book. Our goal is to offer a learning resource that encourages critical thinking and fosters a better, deeper understanding of important ideas.

Each publication is divided into three Sections: Influences, Ideas, and Impact. Each Section has four Modules. These explore every important facet of the work, and the responses to it.

This Section-Module structure makes a Macat Library book easy to use, but it has another important feature. Because each Macat book is written to the same format, it is possible (and encouraged!) to cross-reference multiple Macat books along the same lines of inquiry or research. This allows the reader to open up interesting interdisciplinary pathways.

To further aid your reading, lists of glossary terms and people mentioned are included at the end of this book (these are indicated by an asterisk [*] throughout) – as well as a list of works cited.

Macat has worked with the University of Cambridge to identify the elements of critical thinking and understand the ways in which six different skills combine to enable effective thinking.
Three allow us to fully understand a problem; three more give us the tools to solve it. Together, these six skills make up the **PACIER** model of critical thinking. They are:

ANALYSIS – understanding how an argument is built
EVALUATION – exploring the strengths and weaknesses of an argument
INTERPRETATION – understanding issues of meaning

CREATIVE THINKING – coming up with new ideas and fresh connections
PROBLEM-SOLVING – producing strong solutions
REASONING – creating strong arguments

To find out more, visit **WWW.MACAT.COM.**

CRITICAL THINKING AND *MEANING IN THE VISUAL ARTS*

Primary critical thinking skill: ANALYSIS
Secondary critical thinking skill: CREATIVE THINKING

Erwin Panofsky's 1955 *Meaning in the Visual Arts* is an influential work of analysis and creative thinking. At its heart, Panofsky's collection of essays about visual culture and the way we understand art, deals with nine distinct, but interconnected, subjects as though they are implicitly putting forward arguments. These arguments are mainly concerned with: methods of interpretation, the previously neglected history of the theory of human proportions, the history of art as a humanistic discipline, Albrecht Dürer, * and the Northern Renaissance. * Above all, Panofsky's main concern was his search for both surviving and transformed aspects of the antique heritage in art and literature, together with his identification of the intrinsic meanings of works of art. In this sense, in addition to offering an introduction to Panofsky's most important ideas, the collection can be said to mirror the growth of art history as a scholarly discipline.

Panofsky was explicitly concerned to work out the meaning of each part of his argument. He contended that we must first know what a work of art meant at the time and place of its creation before we can imagine what it ought to mean to us. However, the core of the book reflects the development of Panofsky's iconological approach to art history, that is, the concern with, and identification of, content, subject matter, or meaning in works of art. In doing so, iconology became an indispensable part of art-historical method. Here Panofsky's work can be seen predominantly as a delicate exercise in creative thinking—a critical thinking skill—exemplified by his crossing of disciplines, combined with his vast erudition and deep commitment to a humanistic conception of art and art history. What happens, for example, if the art one wants to study is itself not based on Panofsky's humanistic principles? Would it not be art and, therefore, not considered as worthy of study by art historians? Indeed, understanding Panofsky's methods of interpretation means you might never think about or look at visual arts—particularly paintings—in the same way again.

ABOUT THE AUTHOR OF THE ORIGINAL WORK

Born in Hanover, Germany, in 1892, **Erwin Panofsky** was one of the most influential art historians of his generation. Panofsky was enormously prolific throughout his life, producing dozens of texts, from studies on the Middle Ages and the Renaissance, to film and music. By interpreting works through the themes, symbols, and ideas inherent in the history of art, Panofsky was one the first scholars to cross disciplinary boundaries, and he did so with unparalleled success. His work is considered revolutionary, having a profound effect and helping transform the way a generation of scholars and students looked at and analyzed art.

ABOUT THE AUTHOR OF THE ANALYSIS

Emmanouil Kalkanis was awarded his PhD by the University of Durham for a thesis on visual culture, the reception of art, and the history of collecting. He holds an MA in Museum Studies from Reinwardt Academy, Amsterdam, and has published on the reception of classical art by early-modern artistic practice, including the history of the reception of the iconography of the well-known Meidias hydria. He is currently working for the Greek Ministry of Culture, involved in an excavation project in western Greece, including archeological research, data collecting and object documentation.

ABOUT MACAT

GREAT WORKS FOR CRITICAL THINKING

Macat is focused on making the ideas of the world's great thinkers accessible and comprehensible to everybody, everywhere, in ways that promote the development of enhanced critical thinking skills.

It works with leading academics from the world's top universities to produce new analyses that focus on the ideas and the impact of the most influential works ever written across a wide variety of academic disciplines. Each of the works that sit at the heart of its growing library is an enduring example of great thinking. But by setting them in context – and looking at the influences that shaped their authors, as well as the responses they provoked – Macat encourages readers to look at these classics and game-changers with fresh eyes. Readers learn to think, engage and challenge their ideas, rather than simply accepting them.

'Macat offers an amazing first-of-its-kind tool for interdisciplinary learning and research. Its focus on works that transformed their disciplines and its rigorous approach, drawing on the world's leading experts and educational institutions, opens up a world-class education to anyone.'

Andreas Schleicher
Director for Education and Skills, Organisation for Economic
Co-operation and Development

'Macat is taking on some of the major challenges in university education ... They have drawn together a strong team of active academics who are producing teaching materials that are novel in the breadth of their approach.'

Prof Lord Broers,
former Vice-Chancellor of the University of Cambridge

'The Macat vision is exceptionally exciting. It focuses upon new modes of learning which analyse and explain seminal texts which have profoundly influenced world thinking and so social and economic development. It promotes the kind of critical thinking which is essential for any society and economy.
This is the learning of the future.'

Rt Hon Charles Clarke, former UK Secretary of State for Education

'The Macat analyses provide immediate access to the critical conversation surrounding the books that have shaped their respective discipline, which will make them an invaluable resource to all of those, students and teachers, working in the field.'

Professor William Tronzo, University of California at San Diego

WAYS IN TO THE TEXT

KEY POINTS

- Erwin Panofsky is regarded as one of the most important art historians of the twentieth century.

- *Meaning in the Visual Arts* brings together material from Panofsky's famous works and original papers, as well as translations from the German.

- The book is a landmark collection of essays contributing to our twentieth-century vision of the Middle Ages* and the Renaissance.*

Who was Erwin Panofsky?

Erwin Panofsky, the author of *Meaning in the Visual Arts*, was a German-Jewish art historian, best known for his writings on medieval and Northern Renaissance* art. The basis of his fame is his theory of iconology,* which generated a re-orientation in art history toward the search for meaning instead of the categorization of characteristics of style.

Panofsky was born in 1892 to a wealthy German family of bankers and merchants. After the rise of the Nazi* regime in Germany in the 1930s, he emigrated to the United States, where he pursued most of his academic career. After a year in New York he came to live in Princeton, and in 1935 he was invited to join the Institute for Advanced Study,* while continuing to teach part-time

at Princeton and New York. He brought with him a rigorous training in art historical method and an awareness of the discipline's long history that allowed him to participate with confidence in determining American art history's future. His appointments at Princeton and New York, together with his extraordinary productivity and high profile as public lecturer, ensured Panofsky's distinguished career, and he became a significant influence within the discipline and beyond. This was an extraordinary achievement for an art historian at that time.

During the long course of his writing—more than half a century—Panofsky explored a number of dominant themes. His interests ranged from European Medieval* and Renaissance art to literature and film. The one constant that runs throughout his work, however, was his interest in the development of the field of iconology. His art historical methodology was firmly grounded in German philosophy—specifically that of the philosopher Ernst Cassirer.* His published work was tremendously diverse, embracing cultural and intellectual history, literary criticism, anthropology, philosophy of science, and aesthetics* with one goal: to find the connections between works of art and the cultural context that surrounds them. This range of subjects has also played a formative role in the engagement of a broader readership with the material, a role that positioned Panofsky beyond the boundaries of a single discipline. His ideas have also become the foundations on which much modern-day cultural history and the study of visual culture from a cross-disciplinary perspective has been built. During his life, Panofsky achieved the widest possible recognition for his influential and original art historical studies. Given the influence of his writings (a representative sample of which is presented in *Meaning in the Visual Arts*) and personality, it is not difficult to understand the extent to which he himself was as important as his ideas. Honored above all other scholars in his field for his massive contribution to the history

of art, "he was also a lecturer and teacher of persuasive suggestion and awakening power whose brilliant mind ... had an inspiring effect on the minds of his friends and students."[1]

What Does *Meaning In The Visual Arts* Say?

First published in 1955 (a reprinted edition appeared in 1982 with no significant changes), *Meaning in the Visual Arts* is a collection of nine essays on a range of subjects. The book was compiled while Panofsky was at the Institute for Advanced Study at Princeton. Four of the essays were first written when Panofsky was living in Germany and the rest in the United States. The introduction was originally published in 1940;[2] Chapter One in 1939;[3] Chapter Two in 1921;[4] Chapter Three in 1946;[5] Chapter Four (in collaboration with Friedrich Saxl*) in 1926;[6] Chapter Five in 1930;[7] Chapter Six originally between 1921 and 1922;[8] Chapter Seven in 1936;[9] and the final chapter (Epilogue) in 1953.[10]

The title of the book expresses the author's lifelong attempt to discover and explain what meaning the visual arts actually has. The contents illustrate Panofsky's wide range of interests: "The History of Art as a Humanistic* Discipline;" "Iconography and Iconology: An Introduction to the Study of Renaissance Art;" "The History of the Theory of Human Proportions as a Reflection of the History of Styles;" "Abbot Suger* of St. Denis;" "Titian's* *Allegory of Prudence*: A Postscript;" "The First Page of Giorgio Vasari's* *Libro*: A Study on the Gothic* Style in the Judgment of the Italian Renaissance;" "Albrecht Dürer* and Classical Antiquity;"* "*Et in Arcadia Ego*: Poussin* and the Elegiac* Tradition;" and "Three Decades of Art History in the United States: Impressions of a Transplanted European."

Since its original publication, Panofsky's *Meaning in the Visual Arts* has been standard reading for art history courses. It is not only a comprehensive introduction to the study of art and a profound

discussion of art and life in the Middle Ages and Renaissance, but also a great source of information for those with more specialized interests in these subjects. Written over a period of more than 30 years, the nine essays collected in Panofsky's book demonstrate very well the breadth of the author's knowledge and his groundbreaking ideas throughout his long and distinguished career. This was due first to the international recognition that his search for both surviving and transformed aspects of the antique heritage in art and literature, together with his identification of the intrinsic meanings of works of art in his iconological studies, achieved. Second, it was because these achievements came to shape many subsequent and cultural histories of art. It also suggests that Panofsky's interdisciplinary methodology "was less concerned with the interior dialogue of his own discipline than with its place in the larger context of the humanities* as a whole."[11]

Why Does *Meaning In The Visual Arts* Matter?

In some of his arguments, Panofsky borrowed heavily from others, but he defined those issues that mattered particularly to him by his own innovation, which contributed largely to the rapid development of visual perspective in the arts. Thus, although his work was based "on genuine respect for the achievement of others it was nevertheless revolutionary in character … [and] almost every single one of his publications influenced the development and, more often than not, determined the direction of his chosen discipline, the history of art."[12] For example, his iconological perspective is still very much in the foreground of debates in critical theory from a variety of disciplines. Some of the essays presented in *Meaning in the Visual Arts* were pioneering in the way they skillfully related an abundance of detail to the life and work of individual painters and their times.

Certainly, a comprehensive understanding of Panofsky's iconological interpretation of an artwork is not easy. Thus, although the collected essays can provide students with a well-established

framework for learning how to perceive and appreciate the particular qualities of works of art, careful preparation and reading should be done in order to better understand Panofsky's main ideas. For example, further investigation of the writings of art historians such as Aby Warburg,* Ernst Cassirer, Heinrich Wölfflin,* and Alois Riegl,* and of how their work shaped the discipline's theoretical framework before Panofsky, is necessary to understand the nature of art history in modern historical periods.

Panofsky's *Meaning in the Visual Arts* retains its usefulness as a reference point in discussions of cultural history, art, and visual culture. The individual essays have not only enlivened more than one generation of scholars, but will also introduce many more generations of readers to a love of scholarship best characterized by Panofsky himself. "It may be asked," he wrote, "whether the interpretation of meaning ... apart from satisfying our intellectual curiosity, also contributes to our enjoyment of works of art. I for one am inclined to maintain that it does. Modern psychology has taught us ... that the senses have their own kind of reason. It may well be that the intellect

NOTES

1 Rennselaer W. Lee, "Erwin Panofsky." *Art Journal* 27, no. 4 (1968): 368.

2 Erwin Panofsky, "The History of Art as a Humanistic Discipline," in *The Meaning of the Humanities*, ed. Theodore Meyer Greene (Princeton: Princeton University Press, 1940), 89–118.

3 Erwin Panofsky, *Studies in Iconology: Humanistic Themes in the Art of the Renaissance* (New York: Oxford University Press, 1939), 3–31.

4 Erwin Panofsky, "Die Entwicklung der Proportionslehre als Abbild der Stilentwicklung," *Monatshefte für Kunstwissenschaft* 14 (1921): 188–219.

5 Erwin Panofsky, *Abbot Suger on the Abbey Church of St.-Denis and its Art Treasures* (Princeton: Princeton University Press, 1946), 1–37.

6 Erwin Panofsky, "A Late-Antique Religious Symbol in Works by Holbein and Titian," *Burlington Magazine* 49 (1926): 177–81. See also Erwin Panofsky, *Hercules am Scheidewege und Andere Antike Bildstoffe in der Neueren Kunst*, vol. 18 of Studien der Bibliothek Warburg (Leipzig and Berlin: B. G. Teubner, 1930): 1–35.

7 Erwin Panofsky, "Das erste Blatt aus dem 'Libro' Giorgio Vasaris: Eine
 Studie über der Beurteilung der Gotik in der italienischen Renaissance mit
 einem Exkurs über zwei Fassadenprojekte Domenico Beccafumis," *Städel-
 Jahrbuch* 6 (1930).

8 Erwin Panofsky, "Dürers Stellung zur Antike," *Jahrbuch für Kunstgeschichte*
 1 (1921–2).

9 Erwin Panofsky, "Et in Arcadia ego: On the Conception of Transience in
 Poussin and Watteau," in *Philosophy and History: Essays Presented to
 Ernst Cassirer*, ed. Raymond Klibansky and Herbert James Paton (Oxford:
 Clarendon Press, 1936), 222–54.

10 Erwin Panofsky, "The History of Art," in *The Cultural Migration: The European
 Scholar in America*, ed. W. Rex Crawford and Franz Leopold Neumann
 (Philadelphia: University of Pennsylvania Press, 1953), 82–111.

11 Carl Landauer, "Erwin Panofsky and the Renascence of the Renaissance,"
 Renaissance Quarterly 47, no. 2 (1994): 257.

12 William S. Heckscher, "Erwin Panofsky: A Curriculum Vitae," *Record of the
 Art Museum, Princeton University* 28, no. 11 (1969): 6.

13 Jan Ameling Emmens and Gary Schwartz, "Erwin Panofsky as a Humanist,"
 Simiolus: Netherlands Quarterly for the History of Art 2, no. 3 (1968): 112–
 13.

SECTION 1
INFLUENCES

THE AUTHOR AND THE
HISTORICAL CONTEXT

KEY POINTS

- *Meaning in the Visual Arts* is a collection of groundbreaking individual essays that had a big impact when they were first published during the first half of the twentieth century.

- Building on his New York experience, Panofsky established himself anew as an art historian at the Institute for Advanced Study in Princeton, and became a leading postwar scholar in America until his death in 1968.

- Panofsky was deeply influenced by both the German and American academic environments.

Why Read This Text?

Erwin Panofsky's *Meaning in the Visual Arts* is an enduring collection of essays and articles published by the author over a period of more than 30 years. In this sense, the collection can be said to mirror the growth of art history as a scholarly discipline, in addition to offering an introduction to Panofsky's most important ideas. Although it is in the Renaissance (Panofsky's "spiritual home"[1]) where the author finds his "most formidable challenges,"[2] Panofsky is also capable of authoritatively discussing a whole range of cultural practices and disciplines. Overall, the essence of Panofsky's thinking is that people must first know what a work of art meant at the time and place of its creation before they can imagine what it ought to mean to us now. The extent to which the Renaissance saw the reintegration of classical themes with classical motifs, in contrast to the naive imagery in which classical themes are treated during the Middle Ages,* should also be

> **❝** [Panofsky] was the first to hear clearly, take seriously, and apply systematically to all art, what artists since the Renaissance—Leonardo, Raphael, Dürer, Michelangelo, Titian and the rest—were saying, sometimes desperately: that art is also a function of the brain, that man can speak his mind with his hands. **❞**
>
> Irving Lavin, *Meaning in the Visual Arts: Views from the Outside*

understood as a major theme of Panofsky's writings. However, the majority of his work reflects the development of his iconological approach to art history (i.e., the concern with, and identification of, content, subject matter, or meaning in works of art), as opposed to the stylistic orientation of traditional art history. His work on the subject matter of iconology also marks the turning point at which the latter became an indispensable part of the art-historical method.

The essays in Panofsky's *Meaning in the Visual Arts* deal with both general problems and specific topics involving archeological facts, aesthetic attitudes, iconography,* iconology,* and style. Although the individual essays were not revolutionary when the collection was published in 1955 (most of them had already been published elsewhere), the collection as a whole had a great impact, establishing Panofsky's reputation beyond the narrow borders of his discipline. The book has been one of Panofsky's most successful and widely read texts, becoming a key companion for generations of art history students. Almost 60 years have now passed since its publication, but it still remains relevant, and a key reference point in discussing visual culture and the history of art.

Author's Life
Panofsky was born in Hanover, Germany, in 1892 into a wealthy Jewish family, but was raised in Berlin where his formal education

began at the famous Joachimsthalsches Gymnasium.* After receiving his *Abitur** degree in 1910, he studied philosophy, philology,* and art history at the universities of Freiburg, Berlin, and Munich. Under the supervision of Wilhelm Vöge,* he received his doctorate from the University of Freiburg in 1914. His dissertation on Albrecht Dürer's artistic theory was published a year later.[3] At the age of 28, he was invited to receive his habilitation* from the newly founded University of Hamburg for his thesis on Michelangelo.* In 1916, he married Dorothea "Dora" Mosse, also an art historian. They had two sons, Hans (1917–88) and Wolfgang (1919–2007).

In 1920, Panofsky was appointed *Privatdozent** at University of Hamburg, and five years later he was made the university's first-appointed full professor. In 1934, after the Nazis' assumption of power in Germany and his subsequent dismissal from his post for being Jewish, Panofsky emigrated to the United States. By then, he had already achieved scholarly recognition for his theoretical and historical studies of medieval and Renaissance visual culture. Panofsky worked first at New York University, and then joined the professional ranks of the newly founded Institute for Advanced Study at Princeton as the first permanent member of its School of Historical Studies. There, Panofsky taught and wrote solely in English. Between 1947 and 1948, he held the Charles Eliot Norton lectureship at Harvard University; an honor that Panofsky described as the art-historical equivalent of the Nobel Prize.[4] He retired from the Institute in 1963 as emeritus and was immediately appointed Samuel Morse Professor of Fine Arts at New York University, a post that he occupied until his death on March 14, 1968, at the age of 75.

Author's Background

Erwin Panofsky lived, worked, and researched in both Germany and the United States. Therefore, his professional and academic life was shaped by various influences. Michael Ann Holly* has persuasively

argued that Panofsky's thinking "was itself a product of a certain context, a result of established underlying principles of inquiry that he shared with other thinkers of the time."[5] Indeed, Panofsky arrived at maturity "when German humanistic scholarship had reached the last stage of its world dominance."[6] Thus, the dazzling blend of topics the essays in *Meaning in the Visual Arts* cover demonstrate his theoretical heritage and indebtedness to various personalities. Wilhelm Vöge and Adolf Goldschmidt* were Panofsky's first and most important mentors. As his recently published correspondence reveals, Panofsky never ceased to acknowledge the importance to him of the former.[7] Under their tutelage, Panofsky received his doctorate from the University of Freiburg in 1914. Vöge and Goldschmidt based their scholarship upon keen observation, first-hand experience, and formal iconographical analysis. These scientific methods greatly influenced Panofsky's later work.

Panofsky had many productive years at the University of Hamburg, which was a unique institutional environment for intellectual life and crucial for Panofsky's early scholarship and professional evolution. However, with Jews being forced out of academia and no opportunities on the horizon in Germany, Panofsky moved permanently to the United States in 1934. It is to the credit first of New York University and second of Princeton University "that he found in America an enthusiastic welcome and a suitable environment for the deployment of his extraordinary talents."[8] His involvement with the Institute for Advanced Study would prove to be as stimulating as that with the University of Hamburg. Surrounded by scholars such as Albert Einstein,* Thomas Mann,* and J. Robert Oppenheimer,* Panofsky claimed that he found himself at a place "where members do their research openly and their teaching surreptitiously, whereas the opposite is true of so many other institutions of learning."[9]

NOTES

1 John Rupert Martin, "Meaning in the Visual Arts, by Erwin Panofsky," *The Art Bulletin* 40, no. 2 (1958): 159.

2 Michael Larsen, "Meaning in the Visual Arts, by Erwin Panofsky," *Journal of the Royal Society of Arts* 132, no. 5335 (1984): 478.

3 Erwin Panofsky, *Die Theoretische Kunstlehre Albrecht Dürers* (Berlin: Druck von G. Heimer, 1914–15).

4 Joseph Burney Trapp, "The Letters of Erwin Panofsky Korrespondenz 1910 bis 1968. Eine Kommentierte Auswahl in fünf Bänden," *International Journal of the Classical Tradition* 11, no. 2 (2004): 290.

5 Michael Ann Holly, *Panofsky and the Foundations of Art History* (Ithaca, NY: Cornell University Press 1984).

6 Jan Białostocki, "Erwin Panofsky (1892–1968): Thinker, Historian, Human Being," *Simiolus: Netherlands Quarterly for the History of Art* 4, no. 2 (1970): 68.

7 Trapp, "The Letters of Erwin Panofsky Korrespondenz," 280–92.

8 Rensselaer W. Lee, "Erwin Panofsky," *Art Journal* 27, no. 4 (1968): 368.

9 Erwin Panofsky, *Meaning in the Visual Arts*, (New York: Doubleday, 1955), 322.

MODULE 2
ACADEMIC CONTEXT

KEY POINTS

- The essays in Panofsky's *Meaning in the Visual Arts* are in great part representative of the established intellectual movements of the first half of the twentieth century.

- Panofsky's art history developed as a historical product of previously established intellectual movements.

- Among the most important influences on Panofsky's overall work were Wilhelm Vöge, Adolf Goldschmidt, Ernst Cassirer, Aby Warburg, Alois Riegl, and Karl Mannheim.*

The Work In Its Context

The best way to discuss Erwin Panofsky's *Meaning in the Visual Arts* is to place the art historian in the rich and complex intellectual and socio-political context of his time. Panofsky entered the scene in the aftermath of the World War I,* an uncertain period in Europe, and he made some of the most important contributions to the field of art history before and after World War II.* Thus, the nine essays in *Meaning in the Visual Arts* range from those written in the early 1920s, when Panofsky began to examine the hitherto neglected theories of human proportions and the art of Albrecht Dürer, to his influential work on iconology and iconography. The collection also includes his mid-1940s work on Gothic architecture as represented by the portrait of Abbot Suger of Saint-Denis, and essays written in the early 1950s, when Panofsky had established his reputation as one of the most influential art historians of the twentieth century. It is important to remember this publication history when considering the work's context.

> ❝ To understand why [those] émigré art historians ... placed so much emphasis on the 'rational' interpretation of images, is to comprehend that they feared not only what had happened to Warburg through his exploration of demonology, but more particularly what had occurred in German culture under Hitler, when terror, brutality, and nationalism eclipsed reason, humanity, and the rule of law. ❞
>
> Robert W. Gaston, *Erwin Panofsky and the Classical Tradition*

The nine essays also reflect many of the preoccupations and issues of a period where researchers felt the imperative need for a definite framework within which to study art history. While art-historical philosophy in the nineteenth century had been progressively overwhelmed by diverse and conflicting schools of Subjectivism* and a concern with form* rather than with content,* Panofsky was one of the very first scholars to successfully and convincingly state what the art historian does, or should do. In the 1920s, both sociology* and art history were still consolidating their professional statuses and independence, as compared to philology as the most valued, established and well-resourced discipline in Germany. Unlike America or England, in Germany the humanities were more highly esteemed than the natural sciences. In America, the humanities were largely non-theoretical, and there was no tradition of study comparable to that in Europe. Instead, the status disciplines were the natural sciences, particularly physics. Until the arrival of refugee scholars from Europe, art history in America was regarded as "a weak discipline, although there was a strong tradition in archaeology and the analysis of medieval and classical art."[1]

Overview Of The Field

When Panofsky entered the field, Formalism* was focused exclusively on the aesthetic properties of the artwork and had, as Michael Ann Holly observes, "deliberately, even forcefully, wrenched the object from its historical situation and broader human surroundings."[2] By taking the critical approach to the study of art that was to shape his subsequent writing, Panofsky discovered a new field for the application of his theories. All nine essays in *Meaning in the Visual Arts* are good examples of Panofsky's double achievement, as they introduce and secure a methodology and a system of thought for the discipline of art history. This did not happen immediately, and the collected essays, illustrate this gradual and steady process dating back to the publication of the first essay in 1921. Readers seeking to get a clear view of the fundamental issues of the study of art history during the first half of the twentieth century from Panofsky's text should consider concepts that had already been formulated and discussed by Panofsky's predecessors and teachers, such as Aby Warburg, Ernst Cassirer, Heinrich Wölfflin, and Alois Riegl.

During the years of his lectureship in Hamburg, the Warburg Library (*Kulturwissenschaftliche Bibliothek Warburg*) became Panofsky's intellectual home. Among the scholars he associated with there, Aby Warburg, the founder of the library, and Ernst Cassirer were key figures and influences. Warburg approached art based on historicism and anthropology, juxtaposing at the same time diverse images and materials to illuminate what medieval and early Renaissance people saw in, and sought from, antiquity. This was in opposition to the predominantly stylistic orientation of art history at the time. It was in Panofsky's work on the Renaissance that these methods achieved international recognition. Moreover, while Warburg focused on the late Middle Ages and early Renaissance (c. 1300–1500) as a trial territory, Panofsky extended his reach to other periods from the high Middle Ages (c.1000–1300) through Baroque* and Classicism,*

covering French, German, Italian, and Netherlandish art.

Academic Influences

While in Germany, Panofsky's associations with the resident scholars of the Warburg Library were epistemologically crucial for his professional evolution, although Panofsky was never a part in any organizational sense of the quickly developing *Kulturwissenschaftliche Bibliothek Warburg*. Following Warburg's system, the central motif of Panofsky's work "is the search for survivals and transformations of the antique heritage in literature and art, what Warburg called the *Nachleben der Antike*."[3] It was Panofsky's earlier education, however, under the direction of Wilhelm Vöge and Adolf Goldschmidt, that proved to be of greater influence on his personal intellectual development. This less well-known period in Panofsky's career seems to have been full of interdisciplinary insights and the bold desire to make new meaning rather than perpetuate received knowledge.

Beyond this, Alois Riegl's efforts to explain why visual culture looks different in different times and under different circumstances was also attractive to Panofsky. Karl Mannheim was another influential figure. He created the distinctions between factual, expressional, and philosophical meanings that Panofsky borrowed. However, while the latter's theory of iconology became the dominant paradigm of postwar American art history, Mannheim's theory has remained relatively obscure. Indeed, although Panofsky and Mannheim shared an identical interpretive strategy, they had divergent goals. For instance, as Joan Hart* explains, there is an unmistakable similarity between Panofsky's formulation of his theory of art in the introduction to his 1939 *Studies in Iconology*, an updated version of which is presented in *Meaning in the Visual Arts*, and Mannheim's 1923 essay "On the Interpretation of *Weltanschauung*" (the German original is "Beiträge zur Theorie der Weltanschauungs-Interpretation"), beginning with the anecdote of the meeting of gentlemen in the street that leads to the interpretation

of the meaning of the story using a tripartite, hierarchical schema.[4]

Overall, Panofsky dealt with the theoretical problems of his predecessors in a masterly way. As Jan Białostocki* remarks,"problems of style … and general concepts of art history were analyzed in Kantian* spirit; the problem of the relation of art and ideas in a neo-Kantian,* Cassirerian spirit; and the method of art study, which was later to be celebrated as 'iconology', was conceived in a Warburgian spirit."[5] Finally, the dramatic impact of G. W. Friedrich Hegel's* commitment "to a historical understanding derived from a study of meaningful context" on art-historical thinkers, like Panofsky, has been also stressed in recent scholarship.[6]

NOTES

1 Joan Hart, "Erwin Panofsky and Karl Mannheim: A Dialogue on Interpretation," *Critical Inquiry*, 19, no. 3 (Spring 1993): 565.

2 Michael Ann Holly, *Panofsky and the Foundations of Art History* (Ithaca, NY: Cornell University Press 1984), 24.

3 J. A. Emmens and Gary Schwartz. "Erwin Panofsky as a Humanist." *Simiolus: Netherlands Quarterly for the History of Art* 2, no. 3 (1967–1968): 109. An account of Warburg's influence on Panofsky can also be found in Holly, *Panofsky and the Foundations of Art History*, 105–13.

4 Joan Hart, "Erwin Panofsky and Karl Mannheim," 536, 541.

5 Jan Białostocki, "Erwin Panofsky (1892–1968): Thinker, Historian, Human Being," *Simiolus: Netherlands Quarterly for the History of Art* 4, no. 2 (1970): 71.

6 Holly, *Panofsky and the Foundations of Art History*, 30.

MODULE 3
THE PROBLEM

KEY POINTS

- Although the diverse themes that Erwin Panofsky addresses in *Meaning in the Visual Arts* are not particular to a specific academic question or debate, Panofsky's major concern is meaning.

- The nine essays of the book were originally published over a long period and therefore reflect the intellectual battlefield that existed during the first half of the twentieth century.

- While in Germany, Panofsky lived and learned in the sphere of influence dominated by Aby Warburg and Ernst Cassirer.

Core Question

Many of the themes Erwin Panofsky addresses in *Meaning in the Visual Arts* are particular to Renaissance art and the discipline of art history. The core of the book, however, is the questioning of how meaning is established—through various modes of interpretation—in the visual arts. Indeed, Panofsky's numerous books and articles initiated a methodological approach for reading visual representations from diverse perspectives in regard to geographic places and historical periods. According to H. W. Janson,* who studied under Panofsky in Hamburg, his mentor entered art history at a time when the field was experiencing an identity crisis.[1] The main problem was how to account analytically for stylistic change in Western art over time. Panofsky's Hamburg work contributed to this disciplinary challenge, and his interpretative strategy was original in every respect. It was bound up with the study of Renaissance art.

> ❝ Questions of style were still very much in vogue in art history in the 1930s ... and remained so for the next twenty years or more. Thereafter, style went out of style. Indeed, style became rather a bad word after it was supplanted in the 1950s by the seemingly more concrete and intellectual rewards offered by Panofsky's own methodological trademark, iconology. ❞
>
> Irving Lavin, *Erwin Panofsky. Three Essays on Style*

Interestingly, in a letter to a friend dated April 1, 1962, Panofsky wrote that he did not necessarily try to be original, but rather attempted to avoid the one-sidedness of the great art history tradition of the nineteenth century.[2] What all nine essays in Panofsky's book have in common is the author's desire to draw upon material from many areas of cultural history, looking to define the extent to which the visual arts convey both intellectual sense and aesthetic pleasure. For example, in "Iconography and Iconology," the essay where Panofsky argues for the independence of iconology as a branch of history, he demonstrates how to study a painting so as to understand its meaning. This can be thought of as the anatomy of art—the stages one needs to follow in order to interpret any painting correctly. He also argues for the controlling principles of interpretation: an iconographic analysis on the basis of knowledge of literary sources. Thus, whereas his predecessors were concerned mainly with the classification of artists, styles, and periods, or with the social, religious, and political contexts in which art was produced, or with the psychological and formal principles that determine its various forms, Panofsky was concerned first, last, and foremost with *meaning*. As it has recently been argued, "it was this insistence on, and search for, meaning—especially in places where no one suspected there was any—that led Panofsky to understand art, as no previous historian had

… and in so doing he made art history into something it had never been before, a humanistic discipline."[3]

The Participants

Although he spent half of his life and scholarly career in the United States, Panofsky arrived at maturity when German humanistic scholarship had reached the last stage of its world dominance. Before then, concepts of style, symbol, and symbolic form had already been discussed and formulated by Panofsky's great predecessors. Indeed, Panofsky profited a great deal from the early twentieth-century tradition of scholarship. At a very young age, he took a critical attitude towards the work of Heinrich Wölfflin, one of the most prominent figures in art history at that time. Panofsky believed that style is shaped only by the interpretation of visual expressions, and therefore he uncovered the expressive meaning of stylistic features that he felt was lost in Wölfflin's theory that attempted to show that style—in painting, sculpture, and architecture—follows evolutionary principles, rather than being an intellectual abstraction. Likewise, Panofsky expressed his own view of what came to be known as *artistic volition* (*Kunstwollen*),* a term introduced by Alois Riegl. This dynamic concept was transformed by Panofsky himself from a tool able only to describe the artistic features of different periods (Riegl) to one able to compare the similarities of ideological* and artistic attitudes manifest in the various aspects of one and the same culture.

The central problem that faced historians and art historians of the early twentieth century was that of looking at art from the standpoint of the present. In other words, out of the context of its creation; out of those circumstances or events that led to its making. For Panofsky, the way to solve this was to remain firmly fixed in the culture of the work of art itself, not the culture of the present time. It was not until 1939 that Panofsky published a series of articles/ lectures on iconology, an event that signaled an important turning

point in studying the meaning of a work of art. In the introduction of his 1939 book *Studies in Iconology*, Panofsky establishes his approach with this statement: "Iconography is that branch of the history of art which concerns itself with the subject matter or meaning of works of art, as opposed to their form."[4]

The Contemporary Debate

Panofsky's Hamburg years were an intense period in terms of scholarly activity. Living and learning in the sphere of influence dominated by Warburg and Cassirer, Panofsky learned from them "what he needed without surrendering to the spell of their strong personalities."[5] Warburg was concerned with the role of the classical tradition in European culture (an idea also evident in Panofsky's work), and also interested in the search for signs of thought and life in art. For both men, art was a measure of changing attitudes, outlooks, myths, religions, and superstitions. Moreover, the concept of the symbol, which was at the heart of Cassirer's philosophy at that time, must have also been important in establishing a link between the art historian and the philosopher and, therefore, for the study of culture. It was this philosophy that appeared to be similar to Panofsky's conceptual system. He first mooted these ideas in the introductory chapter of his *Studies in Iconology* using a new term, "intrinsic meaning," referring to an understanding that constitutes the world of symbolic values, such as pure forms, motifs, images, stories, and allegories. Panofsky uses Leonardo da Vinci's* *Last Supper** as an example here, arguing that "as long as we limit ourselves to stating that … [*Last Supper*] shows a group of men around a dinner table, and that this group of men represents the Last Supper, we deal with the work of art as such, and we interpret its compositional and iconographical features as its own properties or qualifications. But when we try to understand it as a document of Leonardo's personality … or of a peculiar religious attitude, we deal with the work of art as a symptom of something else

…"[6] However, only when Panofsky reprinted this essay in 1955 did the conceptual system reach its final form. The discovery and interpretation of intrinsic meaning or content, that is the world of symbolic values (which, according to Panofsky, are often unknown to the artist himself and may even differ from what he consciously intended to express), was formerly described as *iconographical interpretation in a deeper sense*. In the definitive version of the system published in *Meaning in the Visual Arts*, Panofsky called this *iconological interpretation*.

NOTES

1 H. W. Janson, "Erwin Panofsky", *Biographical Memoirs in American Philosophical Society Yearbook 1969–70* (Philadelphia: Buchanan, 1970): 154

2 Quoted in Jan Białostocki, "Erwin Panofsky (1892–1968): Thinker, Historian, Human Being," *Simiolus: Netherlands Quarterly for the History of Art* 4, no. 2 (1970): 71.

3 Irving Lavin, "Panofsky's History of Art," in *Meaning in the Visual Arts: Views from the Outside*, ed. Irving Lavin (Princeton: Institute for Advanced Study, 1993): 6.

4 Erwin Panofsky, *Meaning in the Visual Arts*, (New York: Doubleday, 1955), 26.

5 Białostocki, "Erwin Panofsky," 75.

6 Panofsky, *Meaning in the Visual Arts*, 31.

MODULE 4
THE AUTHOR'S CONTRIBUTION

KEY POINTS

- In *Meaning in the Visual Arts* Panofsky's main aim was to bring a lifetime's work together into one volume. Thus, each individual essay serves a different purpose.

- Panofsky combined classical literature, the history of classical religions, the history of the sciences, the history of law, church history, and above all, mythology, so that they could be viewed in a new light.

- The uniqueness of Panofsky's approach is that by revealing the themes and ideas inherent in the history of art, he deeply examines these themes and ideas as manifestations of our cultural tradition.

Author's Aims

In his *Meaning in the Visual Arts* Erwin Panofsky sets out to represent his lifetime's work. One of his main objectives was to extend the notion of meaning beyond the traditional identification of subject matter. Publishing the collection in English also meant that three of his early essays, originally written in German, became accessible to a much larger audience, Panofsky translated these himself.

Each of the nine essays served a different purpose and had different aims. Among the most significant, "The History of Art as Humanistic Discipline" contains a definition of *humanitas* that may be regarded as the author's credo. This essay also serves partly to suggest the broader context in which art historians should work and partly as an exposition of Panofsky's scholarly manifesto. In "Iconography and Iconology," Panofsky attempts to explain what meaning in the visual arts actually is, his main intention being to give a clear picture of his methodological

> ❝ With an admirable striving for system and with a certain stubbornness he returned ... to those problems, in order to make his concepts more perfect and to eliminate ambiguity ... he succeeded in creating a system which is perhaps the most coherent art-historical method put together in our times. ❞
>
> Jan Białostocki, *Erwin Panofsky (1892–1968): Thinker, Historian, Human Being*

premises. His analysis of the relationship between form and subject matter is intended primarily to introduce the reader to the subsequent chapters of the original 1939 publication. Further, in "The History of the Theory of Human Proportions as a Reflection of the Theory of Styles," the main intention was to emphasize this extremely objective and systematized study adjunct to painting and sculpture. This was a subject that was "generally received with skepticism or, at most, with little interest."[1]

The essay "Abbot Suger of St.-Denis," provides a historical and philosophical background of Suger's life and work. It is a lively sketch of a fascinating and highly intelligent personality, while also acting as a "consummate statement of the historical, philosophical, and artistic moment which saw the creation of Gothic architecture."[2] In his epilogue, "Three Decades of Art History in the United States," Panofsky gives a self-reflective account of his own experiences while researching and teaching art history between the early 1930s and 1950s.

Approach

It is important to clarify that each essay stands alone and should be independently assessed. Some (especially those originally published as introductory parts of larger projects) are somewhat incomplete, so the reader should also seek further illumination in Panofsky's other works.

Panofsky's thinking is based on his conception of art history as essentially a humanistic discipline, mainly because of his need as an art historian to recreate aesthetically the artistic intentions of a work of art. He conceived works of art first of all as objects designed for a practical function: vehicles of communication or tools. In order to qualify as works of art, he argues, they "would have been created not only with an intention of practical use but also of giving an aesthetic experience."[3] In his famous introduction to *Studies in Iconology*, reprinted as the first chapter in *Meaning in the Visual Arts*, Panofsky argued for an art-historical concern for the "intrinsic meaning" of the artwork. "It is in the search for intrinsic meanings or content," he wrote, "that the various humanistic disciplines meet on a common plane instead of serving as handmaidens to each other."[4] He imbued his thinking with the implication that the preservation of the classical tradition in art was a decent and righteous task for art historians. Overall, Panofsky suggested that it is not sufficient to elucidate one work of art by reference to other works of art (like Wölfflin did) or even by reference to other contemporaneous events. He believed that scholars needed to establish some epistemological* principles that would enable them to regard any work in terms of its own intrinsic value. In brief, Panofsky's methodological scheme for achieving a higher understanding of works of Renaissance art involves several formal and empirically controlled stages of analysis. Collectively, these levels teach us how to read images. Images are culturally determined, and if we wish to uncover their hidden meanings, we must familiarize ourselves with the subjects on a variety of levels.

Contribution In Context
Because of the diverse themes presented in the book, a closer look at particular essays is necessary in order to assess how original the author's initial thinking was and the extent to which certain of his ideas changed over time. For example, in the reprinted essays one can

identify those ideas upon which Panofsky's reputation rests, both inside and outside art-history circles. The introductory essay, "The History of Art as a Humanistic Discipline," evaluates and defines the concept of *humanitas*. With its ingenious tables dissecting the three strata of subject matter and meaning, the essay "Iconography and Iconology: An Introduction to the Study of Renaissance Art" was to become the classic statement of iconographic and iconological procedure. In Chapter Three, Panofsky not only translated some of Abbot Suger's writings, but also offered a thorough historical commentary and lively reconstruction of the personality of the founding father of Gothic architecture. Dealing with one of the most famous of Nicolas Poussin's paintings, *Et in Arcadia Ego*, the 1936 essay appears to be an application of the powerful and original construction of Panofsky's theoretical model of iconological analysis, which systematized a practice of art history and theory begun in the 1910s. Finally, among the translations from the German, Chapter Two—which also reveals Panofsky's original contribution to art history scholarship—deals with the problem of human proportions, which was hitherto "generally received with skepticism, or, at most, with little interest … [and which was eventually] abandoned by the [modern] artists and theorists of art."[5] This rewarding and extended inquiry investigates the science of proportion and perspective through which the Renaissance artist sought to establish a harmony between themselves and their environment.

With regard to an individual work of art, questions such as "what did this individual work of art mean in its own time?" had fallen into disfavor. Thus, instead of asking "to which school does it belong?" "who made it?", "what date was it painted?" or even "whom does it depict?" Panofsky was one of the first scholars to seriously discuss *what* exactly does the work of art depict? It was his own original contribution to practice this detailed form of art study within the broad framework of general cultural history.

NOTES

1 Erwin Panofsky, *Meaning in the Visual Arts*, (New York: Doubleday, 1955), 55.

2 Kenneth John Conant, "Abbot Suger on the Abbey Church of St.-Denis and its Art Treasures [Review]," *Speculum* 28, no. 3 (1953): 603.

3 Panofsky, *Meaning in the Visual Arts*, 14.

4 Panofsky, *Meaning in the Visual Arts*, 39.

5 Panofsky, *Meaning in the Visual Arts*, 55, 107.

SECTION 2
IDEAS

MAIN IDEAS

KEY POINTS

- Panofsky's concept of humanistic philosophy and his association with the development of the field of iconology are the most distinctive of the book's ideas.

- Both essays raised issues that were critically important to the development of art history as a branch of the humanities.

- Panofsky presents his ideas in a series of nine essays, which began as the spoken word, as lectures or series of lectures.

Key Themes

The essays collected in Edwin Panofsky's *Meaning in the Visual Arts* deal with a diverse range of topics from the sphere of art history. The key themes, however, are those concerned with: a) Panofsky's famous theory of interpretation; and b) the discipline of art history. These are to be found in the first two chapters of the book.

Firstly, in "Iconography and Iconology: An Introduction to the Study of Renaissance Art," Panofsky distinguished three phases of a critical observation of a work of art: the pre-iconographic, the iconographic, and the iconological. Drawing on previously examined models, Panofsky developed systematic foundations for the discipline of iconology. The articulation of these stages has become a necessary tool in understanding his writings and, therefore, the subsequent chapters of his book.

Secondly, Panofsky re-examines his research methods and critical approach in "The History of Art as a Humanistic Discipline."

> ❝ Panofsky acknowledged the momentous impact that the English language had had on the very foundations of his thinking and on his manner of presenting ideas in a lucid and organic, euphonious as well as logical way— so very different from the 'woolen curtain' that so many Continental scholars, above all Germans and Dutch, interposed between themselves and their readers. ❞
>
> William S. Heckscher, *Erwin Panofsky: A Curriculum Vitae*

Committed to humanist values, Panofsky argued for the paramount role of the humanist interpreter. For him, the humanist is an autonomous individual who cannot exist apart from a well-established and elaborate frame of reference. To the scholar and artist of the Renaissance, that frame of reference was constituted by the heritage of classical antiquity. In order to transfer these ideas to his readers, Panofsky's thinking is surrounded by—but never exclusively dependent on—the extent to which the Italian Renaissance saw the reintegration of classical themes with classical motifs. Thus, as Robert Gaston* stated, Panofsky "certainly endowed his iconology with the implication that the preservation of the classical tradition was a worthy task for art historians."[1] Therefore, the main concepts of the book are encapsulated by Panofsky's vision to build up art history as a respectable scholarly discipline. It was these concepts that took the discipline of art history out of the traditional premises of the early nineteenth century and positioned it firmly as a discipline in its own right.

Exploring The Ideas

The nine essays presented in Panofsky's *Meaning in the Visual Arts* illustrate the great breadth of the author's interests and, in this sense, are of equal quality and importance. However, it is in the introductory chapter, "The History of Art as a Humanistic Discipline," where

Panofsky delivers the main concept of his humanistic philosophy. In this essay, he distinguished between what he felt were the two different meanings of *humanitas*: "the first arising from a contrast between man and what is less than man; the second, between man and what is more."[2] In the first understanding, which was formulated in the circles of the younger Scipio,* *humanitas* is freighted with value. The term distinguishes the *homo humanus* from the barbarian or vulgarian* who lacks *pietas** and παιδεία (paideia*). The second involves the Christian meaning, which in turn displaced the antique meaning in the Middle Ages, where *humanitas* means "a limitation":[3] "The new interest in the human being was based both on a revival of classical antithesis between *humanitas* and *barbaritas* ... and on a survival of the medieval antithesis between *humanitas* and *divinitas*. ... It is from this ambivalent conception of *humanitas* that humanism was born."[4] As J. A. Emmens* and Gary Schwartz* characteristically remark, "it seemed natural to Panofsky to view successive historical periods in terms of thesis, antithesis and synthesis."[5] Thus, Panofsky seems to identify antiquity as the thesis, the Middle Ages as the antithesis, and the Renaissance as the synthesis of European history. This led to a drastically simplified understanding of classical, not to mention Renaissance, *humanitas*. For Panofsky, historical consciousness is what identifies the humanist. By rejecting authority, he thus respects "a tradition consisting of human monuments and documents. Therein lies the difference, for Panofsky, between the natural sciences and the humanities."[6]

Panofsky was also associated with the development of the field of iconology. However, his approach, first presented in the early 1930s, was not systematized as a method until 1939. A clear picture of his methodological premises can be found in the essay entitled "Iconography and Iconology: An Introduction to the Study of Renaissance Art." His main purpose was to deal with the subject matter and meaning of painting in the Renaissance when classical

symbolism was frequently and variously employed. In a refreshingly simple and direct style, he identifies three levels of reading an image: the pre-iconographic, the iconographic, and the iconological. The first description interprets "primary or natural subject matter … identifying pure forms, that is: certain configurations of line and color."[7] It is thus concerned with *factual* and *expressional* meaning, or the recognition of the artwork in its most elementary sense.

The secondary or "conventional" meaning can be discovered or detected only when the viewer is familiar with literary precedents. It is now that the subject of the painting can be identified. As Panofsky explains, "the identification of such images, stories and allegories is the domain of what is normally referred to as 'iconography.'"[8]

Finally, iconology is the subject of a third level of analysis. In the original 1939 essay, this had been called "iconography in a deeper sense,"[9] but by 1955, Panofsky seemed to have become uncomfortable with some of the limitations suggested by the term. He further explains: "the discovery and interpretation of these 'symbolical' values (which are often unknown to the artist himself and may even emphatically differ from what he consciously intended to express) is the object of what we may call 'iconology' as opposed to 'iconography.'"[10]

Language And Expression

The needs of a large audience interested in Panofsky's theories must have played an important role in the book's completion. Firstly, it brings together scattered articles and essays in one volume. Secondly, three of the essays, which are translations from the German, were made accessible to the English-speaking academic community for the first time. As Emmens and Schwartz have also argued, while "his German writings are often difficult, both in the weight of their subjects and the density of their style … in English he carries the reader along. Clearly, effortlessly, he exposes the problem then presents

a solution invariably erudite, amusing."[11] Arguably, had Panofsky remained in Germany, "the history of art written in English would have suffered an immeasurable loss."[12] Overall, the essays are crisp, humorous, and easy to read. As a result of its structure, *Meaning in the Visual Arts* reads like a collection of brief but important insights, rather than a coherent whole. The reader, however, does need to be aware of some of the basic movements and terminology of art history, philosophy, visual culture, and aesthetics of the first half of the twentieth century.

Panofsky largely contributed to the academic vocabulary by introducing new concepts in a memorable way. With the concept of *iconology*, for instance, he introduced a new term to Anglophone art history, and therefore his work has been influential outside his immediate field.

NOTES

1 Robert W. Gaston, "Erwin Panofsky and the Classical Tradition," *International Journal of the Classical Tradition* 4, no. 4 (1998): 618.

2 Erwin Panofsky, *Meaning in the Visual Arts* (New York: Doubleday, 1955), 1–2.

3 Panofsky, *Meaning in the Visual Arts*, 1–2.

4 Panofsky, *Meaning in the Visual Arts*, 2.

5 Jan Ameling Emmens and Gary Schwartz, "Erwin Panofsky as a Humanist," *Simiolus: Netherlands Quarterly for the History of Art* 2, no. 3 (1967–8): 111.

6 Emmens and Schwartz, "Erwin Panofsky as a Humanist," 111.

7 Panofsky, *Meaning in the Visual Arts*, 28.

8 Panofsky, *Meaning in the Visual Arts*, 29.

9 Erwin Panofsky, *Studies in Iconology: Humanistic Themes in the Art of the Renaissance* (New York: Oxford University Press, 1939), 8.

10 Panofsky, *Meaning in the Visual Arts*, 31.

11 Emmens and Schwartz, "Erwin Panofsky as a Humanist," 109.

12 Rensselaer W. Lee, "Erwin Panofsky," *Art Journal* 27, no. 4 (1968): 368.

MODULE 6
SECONDARY IDEAS

KEY POINTS

- Among the most important of the key secondary ideas put forward by Panofsky in *Meaning in the Visual Arts* are those discussing the theory of human proportions; the works of Abbot Suger, Albrecht Dürer, and Titian; and the development of art history in the United States.

- By examining the theories of human proportions from ancient Egypt to the Renaissance, Panofsky emphasizes that it was through the science of proportion, and of perspective in particular, that the artists of the Renaissance established that harmonious relationship between man and his environment.

- In *Meaning in the Visual Arts* there are no major neglected areas or concepts and subjects that have not received critical attention, even when the text was originally published.

Other Ideas

Among the secondary themes of Erwin Panofsky's *Meaning in the Visual Arts*, the most important are those concerned with: a) Human Proportions; b) Abbot Suger; c) Titian's *Allegory of Prudence*; d) Albrecht Dürer and Classical antiquity; and e) the discipline of art history in the United States. Although some of these essays have been more influential and more central to Panofsky's overall work than others, those that are lesser known to the wider audience—and, therefore, less influential—are nonetheless deserving of attention. Probably one of the most important of the above essays is one that discusses the history of theories of human proportions, which as a

> ❝ In that beautiful lecture on *Art History in the United States* which is included in the volume on *Meaning in the Visual Arts* and which, perhaps, conveys his personality with the greatest immediacy, Panofsky speaks of the ideal relation between student and teacher as of the 'joyful and instructive experience which comes from a common venture into the unexplored.' ❞
>
> Ernst Gombrich, *Erwin Panofsky*

study is complete in itself. Here Panofsky presents us with a set of conceptualized procedures, historically discrete, ranging from ancient Egypt to the Renaissance. In the essay on "Abbot Suger of St.-Denis," Panofsky presents a biographical sketch of an outstanding figure in the history of France, discussing a few aspects of his public life and some of the most important characteristics of his method of administration. Next, Panofsky gives an interpretation of a Titian painting with rather intriguing features, including the left profile of a very old man, a beardless youth turned to the right, and the portrait of a middle-aged man in the center. Panofsky's study of "Albrecht Dürer and Classical Antiquity" effectively situates Dürer in the tradition of Italian humanism, thus legitimating the artist as not only an authentic representative of the Renaissance, but also a revered predecessor of German Enlightenment* thinking. Finally, Panofsky's retrospective view of his own presence in the United States over a period of three decades is also an important text in its own right.

Exploring The Ideas

In "The History of the Theory of Human Proportions as a Reflection of the History of Styles," Panofsky examines the theories of human proportions from the Egyptian canons through to those of

Vitruvius* and Polyclitus,* and from the Middle Ages to the time of Albrecht Dürer and Leonardo da Vinci. At one end is Egyptian art where the human figure is presented in a way that disregards the subjective life of the person depicted; it also disregards the position from which the represented figure is thought to be viewed. In contrast, in Classical Greece the subjective life of the figure is expressed in movement. Panofsky concludes by saying that this theory corresponds to the general evolution of art itself. The artistic value and significance of a theory exclusively concerned with the objective dimensions of bodies contained within definable boundaries, he argues, "could not just depend on whether or not the representation of such objects was recognized as the essential goal of artistic activity. Its importance was bound to diminish in proportion as the artistic genius began to emphasize the subjective conception of the object in preference to the object itself."[1] As Panofsky observes, in Egyptian art, for example, the theory of proportions meant almost everything because the subject meant almost nothing.

By giving a historical and philosophical background to Abbot Suger's life and work, Panofsky humorously remarks that to rebuild the basilica of Saint-Denis in a new style "was as if a President of the United States were to have had the White House rebuilt by Frank Lloyd Wright.*"[2] As a thorough commentary on twelfth-century art, religious philosophy, ecclesiastical politics, and general culture, Panofsky's lively, enchanting and fascinating sketch of Suger's personality will "no doubt be for many readers the first and last estimate of the great abbot to fall under their eyes."[3]

Next, Panofsky studies one of Titian's most famous paintings, *Allegory of Prudence*, which "is not only exceptional but unique. It is the only work of his that may be called 'emblematic' rather than merely 'allegorical.'"[4] He tracks down the allegory—the conventional representation of Prudence as a figure with three conjoined heads—to the ancient world, and forward, through the Middle Ages, to the

Renaissance. He also suggests that the three heads shown in the work represent Titian himself in old age, his loyal son Orazio, and his beloved young relative Marco Vecelli.

The essay "Albrecht Dürer and Classical Antiquity" is one of the most rounded accounts of an artist written in our time, rich in subtle observations about the intellectual elements of the artist's art. Here, Panofsky argues that Dürer came to understand classical art not by direct confrontation with it, but by the mediation of Italian Renaissance re-interpretation, which was more readily accessible to him. As Michael Podro* explains, the crucial point of Panofsky's argument was that the understanding of historically distant art is not simply a matter of confronting it, but "involves a process of assimilation and re-interpretation which extends outwards from what is familiar."[5] Indeed, Panofsky showed that Dürer, who had previously been treated as the epitome of the pure mystical German national spirit, was in fact the principal channel through which the classical tradition, reborn in Italy in the Renaissance, was transmitted to Germany transforming its culture forever.[6]

Although isolated from the rest in terms of subject matter and purpose, Panofsky's essay "Three Decades of Art History in the United States: Impressions of a Transplanted European" attempted to suggest what American education might learn from the German university. Panofsky felt that the American university was too often burdened with an excessive "teaching load … a disgusting expression which in itself is a telling symptom of the malady I am trying to describe."[7] For Panofsky, the American method of producing scholars was not suited to make humanists: he believed that humanists cannot be "trained," they must be allowed to mature or, "if I may use so homely a simile, to marinate."[8] This last essay, the epilogue of the book, comes as a short presentation of a professional framework within which Panofsky's academic endeavors and lasting achievements had successfully taken place.

There are close theoretical associations between the different themes in *Meaning in the Visual Arts*. Overall, the problem of what and how and for whom works of art are significant, remains an enduring question underlying most of Panofsky's key as well as secondary themes. However, there seem to have been issues that have not been really settled in Panofsky's formal statement of his iconological method (Chapter One), but they are raised in an implicit and problematic form in an essay written earlier, which deals with Titian's *Allegory of Prudence*. As Stephen Bann* explains in reassessing the modes of strong interpretation advocated in the book, "Panofsky's analysis of Titian's *Allegory of Prudence* demonstrates, in an almost exaggerated way, the odd distortions implicit in the use of the iconographic and iconological method."[9]

Overlooked

Although the nine essays in *Meaning in the Visual Arts* deal with various topics, they all demonstrate Panofsky's major theoretical concerns. They demonstrate his method of research and the critical approach to his chosen subject, one that endowed his thinking with a desire, firstly, to preserve the classical tradition, and, secondly, to approach art based on historicism and anthropology. Also, the range of material he drew together through his cross-disciplinary acquaintance was extraordinary, and allowed readers to focus on the significance of Panofsky's thinking and follow his narrative with ease.

Due to the diverse nature of the text, it is difficult to ascertain whether some of the secondary ideas in it have been overlooked in subsequent scholarship, or whether they have failed to have the impact their significance deserves. One important aspect that should be held to account here, however, is that the fractured nature of these essays (some are parts of longer texts written and published in the 1920s, 1930s, and 1940s) does not mean that they cannot stand alone as valuable pieces. Additionally, some of them attracted more attention

and exerted more influence than others. For instance, Panofsky's essay on iconography and iconology, where he gives a clear picture of his methodological premises in regard to the latter, has been powerful and instrumental not only in the subsequent development of the discipline of art history, but also in the attention it attracted from other scholars.

There are themes that did not attract as much attention as the iconography essay, but that does not mean they are not insignificant. The essays on Suger and Dürer, for example, are key accounts of two influential personalities and significant in their own right. Finally, Panofsky's study of the previously neglected science of human proportion and perspective, in particular, is of great importance as it

NOTES

1 Erwin Panofsky, *Meaning in the Visual Arts*, (New York: Doubleday, 1955), 105.

2 Panofsky, *Meaning in the Visual Arts*, 134.

3 M. D. Knowles, "Abbot Suger on the Abbey Church of St.-Denis and its Art Treasures [Review]," *The English Historical Review* 63, no. 257 (1948): 236–7.

4 Panofsky, *Meaning in the Visual Arts*, 147.

5 Michael Podro, *The Critical Historians of Art* (New Haven and London: Yale University Press, 1982), 185.

6 Irving Lavin, "Panofsky's History of Art", in *Meaning in the Visual Arts: Views from the Outside*, ed. Irving Lavin (Princeton: Institute for Advanced Study, 1993), 6.

7 Panofsky, *Meaning in the Visual Arts*, 341.

8 Panofsky, *Meaning in the Visual Arts*, 341.

9 Stephen Bann, "Meaning/Interpretation", in *The Art of Art History: A Critical Anthology*, ed. Donald Preziozi (Oxford: Oxford University Press, 2009), 258.

10 Panofsky, *Meaning in the Visual Arts*, 105.

MODULE 7
ACHIEVEMENT

KEY POINTS

- With *Meaning in the Visual Arts*, Panofsky achieved his goal of becoming one of the major exponents—undoubtedly the most prominent one—of the concepts of iconography and iconology to a large English-speaking audience.

- *Meaning in the Visual Arts* breathed new life into various concepts of art-historical thinking and greatly influenced the development of the discipline.

- Panofsky's nine essays in *Meaning in the Visual Arts* vividly demonstrate the extent to which his contribution to the discipline of art history was universal, embracing painting and literature as well as sculpture, architecture, and history.

Assessing The Argument

Because of the diversity of themes and ideas in Edwin Panofsky's *Meaning in the Visual Arts*, it is difficult to ascertain whether the author has been successful in realizing his intention. However, the huge impact of his work, both in the form of individual texts and completed books, indicates that whatever his aims had been, he was successful in making various original contributions to the fields of art history and visual studies. Overall, Panofsky is important to the present not because "he resonates with contemporary grand theory ... but because he bridges so well the two cultures: he makes us realize what is valuable in the ethos of both scientific and humanistic inquiry and how each is relevant to studying complex cultural phenomena."[1] Moreover, Panofsky's career has been one of the greatest influences on modern art-historical writing, with his method of iconology being his

> **❝** [Panofsky] enabled us to argue in detail about humanist scholarship without feeling that we were lost in the pursuit of details that had no larger sense. We owed him intellectual confidence—a hard emotion for intellectual historians to cultivate ... No wonder that his elegant formulations inspired so much research and teaching. **❞**
>
> Anthony Grafton, *Meaning in the Visual Arts: Views from the Outside*

achievement.

The breadth of subjects covered—from the Middle Ages to the sixteenth century, and from the visual arts to literature, philosophy, and the sciences—is the most impressive feature of the book. Not only is Panofsky's writing authoritative, critical, and ruthlessly analytical, but it also establishes his subject as part of the broader field of intellectual and cultural history. In turn, this instructs and inspires all those who are interested in other aspects of cultural history. As Paul Oscar Kristeller* writes, Panofsky "conceives of the visual arts as part of the universe of culture that also comprises the sciences, the philosophical and religious thought, the literature and scholarship of the Western world in the various phases of its history."[2] This is the kind of "true humanism," he continues, "of which we are badly in need, and in spite of our present grim outlook, there is some hope for the future of our civilization as long as it is being upheld by scholars of Panofsky's caliber."[3]

Achievement In Context

Meaning in the Visual Arts is important for two principal reasons. First, it created an avenue for visual arts by significant crossing of disciplines. Before the book's publication, European scholars were stumbling

along a Nazi-inflected socio-cultural landscape, using concepts inherited from previous art-historical writings. Panofsky brought about an entirely new vocabulary that gave new life to art-historical thinking and the interpretation of an artwork. Second, the book made it easy for non-German-speaking scholars and students to study Panofsky's earlier works, some of which are key to a better understanding of the development of his core ideas. Indeed, unlike many of his fellow German scholars, and also due to his excellent command of the language, Panofsky's choice to write exclusively in English was a crucial step in his work becoming universally applicable. In doing so, he got rid of the obscure meanings that made his German writings so dense and difficult to follow for a novice reader. Overall, Panofsky's work is still a presence not only on the level of small details and large conceptual concerns, but also as a focal point of controversies about more general modes of interpretation of artworks. Although from a contemporary or postmodern* standpoint his writings display both weaknesses and strengths, Panofsky destabilized and challenged the well-established disciplinary boundaries before him. His contributions to the development of art history as a scientific discipline proved to be pioneering. *Meaning in the Visual Arts* became a key work in cultural and art-historical studies, and his ideas had a tremendous influence on the discipline in the first half of the twentieth century. From that point onward, the individual essays of the book became a vital reference point in debates in this field.

Although European scholars had already been in the forefront of the study of art history, the notion that art history in America before Panofsky's arrival was a dry archeological discipline awaiting the life-giving touch of a German tradition of art historical scholarship, is historically uncertain and quite debatable. Conversely, "the animating impulse deriving from the teaching and scholarship of the Germanic immigrants was especially potent in American art history because

many were suave disseminators of a humanistic approach to the Renaissance."[4]

Limitations

By illustrating the remarkable breadth of the author's interests as well as the wide span of his cross-disciplinary pursuits, Panofsky's essays vividly show that he refused to confine his thought within certain disciplinary boundaries. Thus, his core ideas (most of which are presented in this volume) seem to have been always at the forefront of theoretical developments and hugely influential, even beyond the borders of the discipline of art history. However, it is difficult to judge the extent to which the various issues covered in *Meaning in the Visual Arts* apply to a particular time or place, or if they have been interpreted differently by readers from different disciplines. The essays bring together a variety of subjects, illustrating very well Panofsky's interests in the whole expanse of human culture. Thus, although the Renaissance occupies the text's central ground, Panofsky ranges freely and authoritatively over material that covers issues from ancient Egypt, the Middle Ages and Classical antiquity to Netherlandish art and twentieth-century American education. In this respect, the argument that his contribution to the history and the theory of art had a kind of universality, embracing sculpture, painting, and architecture, as well as the literature and learning of many centuries, should not be seen as exaggerating Panofsky's position in art history.

Additionally, the fine scholarship and success of Panofsky's collected essays testifies to the recognition that gradually began to reach beyond the narrow circle of art historians, and also beyond the English-speaking world "even in Germany and France, which for a long time had not been very interested in what was going on in the field of the humanities outside their own borders."[5] Indeed, *Meaning in the Visual Arts* reached the French public, in Bernard Teyssèdre's* translation, in 1969.

Panofsky could never accept the modern separation of form and expression from content—in the most traditional, iconographic sense. Thus, his unexpressed conclusion that an artwork empty of images couldn't be humanistic art could be the reason for his silent condemnation of contemporary painting. The fact that Panofsky established a layered and deliberate method, requiring an advanced education both about the work of art itself, and also about its culture of origin, should also be considered both an obstacle and a limitation

NOTES

1 Ralph A. Smith, "'What Is Art History?' Panofsky and the Foundations of Art History, by Michael Ann Holly [Review]," *Studies in Art Education* 28, no. 3 (1987): 180.

2 Paul Oscar Kristeller, "Renaissance and Renascences in Western Art, by Erwin Panofsky [Review]," *The Art Bulletin* 44, no. 1 (1962): 67.

3 Kristeller, "Renaissance and Renascences," 67.

4 Robert W. Gaston, "Erwin Panofsky and the Classical Tradition," *International Journal of the Classical Tradition* 4, no. 4 (1998): 616–7.

5 Jan Białostocki, "Erwin Panofsky (1892–1968): Thinker, Historian, Human Being," *Simiolus: Netherlands Quarterly for the History of Art* 4, no. 2 (1970): 70.

PLACE IN THE AUTHOR'S WORK

KEY POINTS

- Panofsky's *Meaning in the Visual Arts* is the culmination of a life's research; an enduring collection of some of his most significant art-history essays and articles written and published since the early 1920s.

- Panofsky's *Meaning in the Visual Arts* is itself, in fact, a representative sample of the scholar's whole body of work gathered together to better explain his key ideas to a much wider audience.

- When *Meaning in the Visual Arts* was published, the author was already recognized as one of the foremost art historians of his generation.

Positioning

Edwin Panofsky's *Meaning in the Visual Arts* is a collection of old and revised material, and although some of the essays can be considered the product of early work, it is certainly the culmination of his life's research. The reader can find in them numerous references and connections to the great breadth of his interests and the remarkable amount of scholarship the author produced over a 50-year scholarly career. His various and deep insights on the work of Albrecht Dürer are characteristic examples.

By the time Panofsky was forced to leave Hamburg because of the Nazi regime, he had already published extensively (in German) on medieval and Renaissance imagery. His doctoral dissertation on Albrecht Dürer's art theory (*Die Theoretische Kunstlehre Albrecht Dürers*) was not the first work of his to receive scholarly acclamation. He had previously won the coveted Hermann-Grimm Prize from Berlin

> ❝ How he was able, year after year, without an institute
> and without a large staff of assistants, to produce
> fundamental studies in one area after another will very
> likely remain his secret, along with his ability to carry
> on a lively and valuable professional correspondence
> with anyone on art history on any topic; another aspect
> of his humanism. ❞
>
> H. Van de Waal, *In Memoriam Erwin Panofsky*

University for his study of the Italian-inspired mathematics in Dürer's work that anticipated his *magnum opus*, *Albrecht Dürer* (1943). He also worked on Dürer's *Melencolia I*, a documented description of the survival and transformation of various antique themes in Christian art, and German sculpture and painting (eleventh–fifteenth centuries), and the philosophy of art. In 1933 Panofsky moved permanently to the United States; his later works were written in English.

Panofsky's great fame, however, still rests on his influential work on iconology, exclusively dedicated to the transformations of the antique heritage in Renaissance literature and art. The most significant transformation, for instance, refers to the three levels of meaning (the pre-iconological, the iconographic, and the iconological) in pictorial representation in every visual image. Traces of Panofsky's most influential methodological framework can be found in two earlier essays. The first was written in 1932 in German ("*Zum Problem der Beschreibung und Inhaltsdeutung von Werken der Bildenden Kunst*") and the second in English in 1939 ("Studies in Iconology"). Panofsky republished the latter with a two-paragraph addition in *Meaning in the Visual Arts*. Although the 1932 essay is the first, and arguably the fundamental statement of what would later come to be called the theory of iconology, Panofsky modified his conclusions in 1939 and again in 1955 (*Meaning in the Visual Arts*),

showing "not only a trajectory of his art-historical thinking but also a fundamental cultural transformation."[1]

Integration

Panofsky's recognition as being one of the most prominent art historians of his generation is based on his numerous seminal and original publications in the field over a period of 50 years. His influence can be seen in the massive invasion of historical studies by iconographic and iconological, as well as semiological* investigations, which add a visual dimension to traditional views of historical phenomena. Thus, through fine scholarship and an exceptional use of the English language, Panofsky's seminal work eventually demonstrated the extent to which his inquiries into the various and distinctive ways in which Medieval and Renaissance images function as artistic representations of larger cultural and intellectual ideals, have shaped many subsequent social and cultural histories of art.

The corpus of Panofsky's academic publications, some 18 books and 80 articles, rightfully mirrors the growth of art history as a scholarly discipline. Most of his publications began as lectures or series of lectures. They are all great examples of the extent to which a scholar knows how to preserve the "character of the oral argument, even in his most formal writings."[2] However, Panofsky's interests went beyond the premises of art history. In 1936, he delivered a lecture on film at the Metropolitan Museum of Art in New York that was subsequently published as "Style and Motion in the Motion Pictures," in *Critique* in 1947. This was the earliest treatment of the subject by a respected scholar of art history, and probably Panofsky's most reprinted work.

Significance

The impact of Panofsky's work on twentieth-century intellectuals, including literary critics, cultural and intellectual historians,

anthropologists, and philosophers of science, among others, far exceeds the boundaries of a single discipline and hence should not be forgotten. Panofsky was at the epicenter of art-historical developments until the 1960s, and even during the 1970s and 1980s he remained certainly present on the art-historical scene. This influence, however, would not last for ever. He eventually came to be regarded as the "burdensome father figure from a bygone period of humanistic scholarship."[3] Various reactions against his approach to the problems of interpretation cast a shadow over a widespread admiration for his erudition, brilliance, and open-mindedness. The reasons for these reactions are complex, so cannot be discussed in much detail in the limited space of this analysis. In addition, the iconological system Panofsky developed with such dashing success from 1930 to the mid-fifties was not without flaws. For some, the process of traditions of images as Panofsky reconstructed it, was "tortuous, fortuitous, full of uncertainty, past echoes, and unexpected turns. It absolutely does not possess a logic; it has no constant direction, no goal."[4] For others, the epicenter "of the 'earthquake' which was to shutter and break up Panofsky's whole system of interpretation … was situated in the field of literary criticism."[5] It was the massive impact of structuralist* and poststructuralist theories—semiotics, deconstructivism,* and reception*—which since 1980 began to put into question the very foundations of Panofsky's concept of the history of art as a humanistic discipline.

NOTES

1 Jas Elsner and Katharina Lorenz, "The Genesis of Iconology," *Critical Inquiry* 38, no. 3 (Spring 2012): 492.

2 William S. Heckscher, "Erwin Panofsky: A Curriculum Vitae," *Record of the Art Museum, Princeton University* 28, no. 1 (1969): 6.

3 W. J. T. Mitchell, "What is Visual Culture?" in *Meaning in the Visual Arts: Views from the Outside*, ed. Irving Lavin (Princeton: Institute for Advanced Study, 1993), 215.

4 Giulio Argan and Rebecca West, "Ideology and Iconology," *Critical Inquiry*, 2, no. 2 (Winter, 1975): 298–9.

5 Willibald Sauerländer, "Struggling with a Deconstructed Panofsky," in *Meaning in the Visual Arts: Views from the Outside*, ed. Irving Lavin (Princeton: Institute for Advanced Study, 1993), 385–6.

SECTION 3
IMPACT

MODULE 9
THE FIRST RESPONSES

KEY POINTS

- Reactions to the ideas presented in *Meaning in the Visual Arts* were diverse and came from scholars of different academic backgrounds.

- Panofsky did not live long enough to respond to the numerous critics of his ideas.

- Panofsky himself knew the strengths and weaknesses of his methodology, and attempted to revise some of his original ideas later on.

Criticism

The essays collected in Edwin Panofsky's *Meaning in the Visual Arts* represent very well the range and depth of his scholarship over a period of more than 30 years, and it would have been impossible for the collection not to have attracted critical attention. The majority of criticism was directed at Panofsky's ideas and methodology rather than to the individual essays per se.

Panofsky's use of iconology as a principal tool for analyzing an artwork attracted the most criticism. Otto Pächt,* for instance, criticized the limitations of Panofsky's iconological method. Pächt believed that this method, which is based on Renaissance art, "wrongly became the basis for all art-historical analysis." He also questioned "whether, although a modern viewpoint gave us access to a work of art that was previously a closed book, there was anything to guarantee that what was seen was true and authentic, rather than a total distortion."[1]

> ❝ The history of a discipline, like the history of, say, politics or art, requires for its telling the identification and understanding of major events. In the history of modern art history, the primary 'event' is undoubtedly the work of Erwin Panofsky. His great influence, however, is counterbalanced by fairly widespread incomprehension of the exact nature of his thinking. ❞
>
> Michael Ann Holly, *Panofsky and the Foundations of Art History*

The criticism of Panofsky's work on Abbot Suger is limited to the scant attention he gives to the architectural aspect. John Hooper Harvey* argues that this aspect is "not dealt with quite so meticulously as could be wished with texts of crucial importance."[2]

Panofsky was even accused of a lack of interest in form—in art itself. Others rushed to his defense. Jan Białostocki argued that "everybody who knew [him] knows how false such an opinion is, and that this kind of criticism was altogether unjust. But it is certainly true that his main interest was in meaning, which he saw everywhere and which he knew how to reveal to others."[3] In regard to Panofsky's definition of the history of art at the beginning of the concluding essay in *Meaning in the Visual Arts*, it has recently been argued that it represents a kind of loss. Randolph Starn* remarks in particular, that not only does this definition "limit art history to one modern professional branch whose native tongue is German; it also excludes plenty of German art historians and whole collateral, disciplines concerned with the visual arts in one historical context or another."[4]

Responses

Panofsky did not live long enough to respond to the numerous critics of his ideas, although in later publications, he subsequently revised and developed his thinking. For example, his *Renaissance and Renascences*

(1960) includes a revision of many of his earlier ideas. As James Ackerman* writes in his review, "it is what artists would call a Panofsky retrospective, enriched by new perceptions, which will delight old admirers and give the novice a more coherent introduction to this method than the miscellaneous articles collected in … *Meaning in the Visual Arts*."[5]

A few responses to criticism or to issues that seemed to trouble him can also be found in his correspondence.[6] In a letter of August 24, 1965, Panofsky answers those who questioned his disregard for the aesthetic experience of a man-made object. He defines the latter as the object of his study: "I am the last to deny … that *every* man-made object produced with a purpose is (or rather *can* be) a legitimate object of 'art' historical or 'art' critical investigation—if and when it has an 'aesthetic' intention together with an infinite variety of others. However, the fact remains that *we ourselves* must realize and qualify that 'intention' (otherwise there will be no rational difference between the descriptions of a motor car by an engineer and an art historian); and for this rationalization and qualification we need to explore what the artist had in mind—including, in *certain* cases, iconological content and, in all cases, an autonomous frame of reference."[7]

Conflict And Consensus

Panofsky's own revisions appear to be motivated more by a sense that the methods of analysis put forward in his key ideas are constantly changing, rather than by the criticisms leveled against it. These limited revisions show a degree of cautiousness as to what—and if—something needs to be chiefly revised. However, regardless of the criticism, Panofsky himself knew the strengths and weaknesses of his iconological system. Therefore, only when he reprinted the introductory essay of his *Studies in Iconology: Humanistic Themes in the Art of the Renaissance in Meaning in the Visual Arts* did the iconological system achieve its final form.

One of the serious shortcomings of Panofsky's approach to images was his unwillingness to deeply explore the social matrices in which they were produced and used. However, patronage studies arising in the 1960s and 1970s, partly from the work of Friedrich Antal* and Francis Haskell,* sought to cover this gap.[8] Historians such as Richard Goldthwaite,* F.W. Kent,* and Richard Trexler* have also shed new light on the place of architecture and art objects within the social, economic, and religious life of the Renaissance, "thereby modifying our views of the place that the classical stream in Renaissance art and patronage ought to be accorded."[9]

No matter how deep, serious, and enduring the above criticism has been over the years, there was only a short step to the misunderstanding that Panofsky was mainly interested in texts explaining the meaning of symbols and images, and that he did not intend to respond to the formal qualities of art. As Ernst Gombrich* has put it, "to think of his contribution as principally confined to iconography means indeed to miss the historical position and the true purpose of Panofsky's great oeuvre."[10]

NOTES

1 Jonathan Harris, *The New Art History: A Critical Introduction* (London and New York: Routledge, 2011), 38; Otto Pächt, *The Practice of Art History: Reflections on Method*, 1st English edn (London: Harvey Miller, 1999), 28–9.

2 John H. Harvey, "Abbot Suger on the Abbey Church of St.-Denis and its Art Treasures [Review]," *Burlington Magazine* 89, no. 537 (1947): 348.

3 Jan Białostocki, "Erwin Panofsky (1892–1968): Thinker, Historian, Human Being," *Simiolus: Netherlands Quarterly for the History of Art* 4, no. 2 (1970): 83.

4 Randolph Starn, "Pleasure in the Visual Arts," in *Meaning in the Visual Arts: Views from the Outside*, ed. Irving Lavin (Princeton: Institute for Advanced Study, 1993), 152.

5 James S. Ackerman, "Renaissance and Renascences in Western Art [Review]," *The Journal of Aesthetics and Art Criticism* 19, no. 3 (1961): 350.

6 Dieter Wuttke, ed., *Erwin Panofsky: Korrespondenz 1910 bis 1968: Eine Kommentierte Auswahl in Fünf Bänden*, 5 vols (Wiesbaden: Harrassowitz Verlag, 2001–11).

7 Białostocki, "Erwin Panofsky (1892–1968)," 83–4.

8 See, for instance, Francis Haskell, *Patrons and Painters: A Study in the Relations between Italian Art and Society in the Age of the Baroque* (New York: Alfred A. Knopf, 1963).

9 Robert W. Gaston, "Erwin Panofsky and the Classical Tradition," *International Journal of the Classical Tradition* 4, no. 4 (1998): 621.

10 Ernst H. Gombrich, "Erwin Panofsky", *The Burlington Magazine* 110, no. 783 (June 1968): 359.

MODULE 10
THE EVOLVING DEBATE

KEY POINTS

- Regardless of any intellectual debates and criticism, Panofsky's theories exerted huge influence and have been at the forefront of art-historical (theoretical) developments for more than seven decades.

- Panofsky's work, which culminates in *Meaning in the Visual Arts*, is undoubtedly one of the primary components in the development of modern art history.

- Focusing on the elusive *meanings* of works of art, scholars from art history and beyond continue to demonstrate their special debt to Panofsky's work.

Uses And Problems

At the time of his death in 1968, Edwin Panofsky, the author of *Meaning in the Visual Arts*, was a widely respected scholar. However, due to the nature of *Meaning in the Visual Arts* (collected essays published by the author over a period of more than 30 years), any attempt to trace its influences on the subsequent evolution of art history would require a closer look at the ideas each individual essay contains. For example, Panofsky's iconological studies may produce brilliant results, which are of interest not merely to specialized students and scholars, but to all who wish to enlarge their enjoyment of art through a better understanding of what they are looking at.

Among the various attempts to modernize Panofsky—to link, in other words, his theories to contemporary developments in the humanities—is Michael Ann Holly's comparison of Panofsky's early theoretical essays with the work of Michel Foucault.* In doing so,

> ❝ Recent art-historical criticism has turned, in part, against Panofsky's iconology: revisions to Panofsky's methodology shift focus from textual sources to pre-discursive and material relationships to art objects. But the influence of Panofsky cannot be overestimated: the collective humanistic scholarship of the Warburg circle would provide the basis for multiple fields across the humanities in the twentieth century. ❞
>
> Emily J. Levine, *The Other Weimar: The Warburg Circle as Warburg School*

Holly finds Panofsky's vision of iconology worth our attention because of its mainly humanistic underpinnings and multidisciplinary character.[1] However, Svetlana Alpers* has argued against the usefulness of iconology, asserting that it is not well equipped to deal with the nature and function of art in any given society at any given time. Alpers also attacked the institutional base of traditional art history for using models of art derived from analytical methods of the Italian Renaissance, such as Panofsky's iconography. Such methodological models, she claimed, would be inappropriate and insufficient to understand, for example, Dutch painting, and should not be used.[2] Finally, Panofsky's introductory essay "The History of Art as a Humanistic Discipline," which has long been considered by academia as a standard definition and defense of the study of art history, can now be seen as based in Renaissance assumptions about man and art. What happens, however, "if the art one wants to study is itself not based on such humanistic principles? Is it not art? Can it not be studied by art historians?"[3] Ernst Gombrich was another influential thinker who identified and commented on the pitfalls of iconological research. Although Panofsky's methods never attracted any polemical critique from Gombrich, they provided him with a jumping-off point for more

discussion and critical assessment, as he saw the unquestioning "application of … existing and ready-made paradigms* [for example, Panofsky's iconology] as a threat to the health of our search and research."[4] Rensselaer Lee* writes with a dose of hyperbole that Panofsky's method, "subject to danger in the hands of lesser men, is a powerful instrument for the study and control of content, for demonstrating 'the real relevance of works of art for the study of history' and herein lies its great importance for the historiography* of art."[5]

Schools Of Thought

Panofsky's collected essays discuss a variety of issues and ideas, thus attracting or inspiring many writers and thinkers. Commenting on Panofsky's famous studies in iconology, Giulio Argan* argued a few decades ago, that the subject had become a living testimony to the imagination of its originator: "[Iconology] certainly would be possible and it would be a very useful kind of research, one to recommend to young art historians desirous of exploring new fields … In many respects, then, the iconological method … can be qualified as the most modern and efficacious of historiographic methods."[6] Indeed, Panofsky's iconology offers a perfect model for the bridging of distinctions between different fields of historical research and, therefore, addressing itself to the elusive underlying cultural principles of representation, that is, how meaning becomes expressed in a specific visual order and why certain images or attitudes have assumed one particular shape at one particular time.

Panofsky's legacy is evident through his writings, but also through the work of those who learned from him. In spite of the fact that he denied it, he was "the creator of a system and a method, he was also the nucleus of an international group of scholars, of something like a 'clan' of art historians bound up with him … by the direct links of the teacher-pupil relation"[7] or by a more distanced connection or

influence by breathing new life into Panofsky's thought-provoking ideas. As William S. Heckscher* writes, "many of Panofsky's students and disciples of Hamburg days, all indeed distinguished scholars in their own right, have successfully carried on and developed, often in ways quite remote from those of their great teacher, this Panofskian blend of the humanist tradition."[8]

Due to the complex nature of Panofsky's *Meaning in the Visual Arts* as a collection of essays on a great range of subjects, it is hard to identify any particular schools of thought in the ideas it contains. One thing that can be established with certainty, however, is the fact that Panofsky's key ideas have inspired and challenged academics of many different disciplines, and continue to do so. For example, the school of art-historical hermeneutics* launched one of the most significant critiques of Panofsky's ideas, with Oscar Bätschmann* as its principal exponent. The school aimed to move away from the sometimes vague notion of "meaning" generated by iconologists in order to concentrate on a meaning that primarily resides in the pictorial level of the work of art itself.[9] For others, it is virtually impossible to remove a photographic image from its particular social context and go beyond Panofsky's first, pre-iconological level of analysis without emotional attachment.[10] Taking iconology to be the result of a method rather than the technique itself, Creighton Gilbert* also argues that the iconologist's problems begin just at that point when they decide not to stay with the iconographic evidence but to carry on into the deeper content and significance of the work itself.[11]

In Current Scholarship

Panofsky's nine essays cover a wide variety of subjects, and therefore it is difficult to ascertain who the current proponents of the text are. Additionally, and like any vigorous intellectual construct, ideas change over time. Therefore, due to the evolution of the discipline of art history, such interdisciplinary pursuits have now more generically

renamed "visual and cultural studies" rather than iconology.

Throughout the years, many of Panofsky's views have also been elaborated upon and expanded by a number of scholars, and, although iconology had been mostly applied to representational arts, such as painting and sculpture, architectural historians in particular also use this method in their studies. For example, Rudolf Wittkower,* Panofsky's friend and disciple, became a prime proponent of the iconological method and was fascinated by the way a motif could travel independently of meaning.[12] Following Panofsky's work on the history of the theory of human proportions, Wittkower's concept of proportion is related to architecture and, therefore, demonstrates his affinity with Panofsky's work. It seems that the philosopher Claude Lévi-Strauss* was also impressed by the hierarchical lucidity of iconological interpretation that Panofsky proposed. Indeed, in his discussion of the three Graces in Botticelli's* work "La Primavera" (Uffizi Gallery, Florence), Lévi-Strauss emphasizes the "principal significance of Panofsky's iconographic and iconologic analyses," and rejects, in the same breath, any kind of analysis of art that is purely concerned with form.[13]

In *An Introduction to Iconography: Symbols, Allusions, and Meaning in the Visual Arts*, Roelof van Straten* also raises fundamental issues about iconography that have scarcely been examined since Panofsky. Van Straten adheres to Panofsky's three stages of research procedure, his only departure from this formula being the separation of iconology into what he calls "iconographic interpretation" and "iconology." While for him, *interpretation* uncovers metaphorical meanings intended by the artist, which would have been readily interpretable by his contemporaries, *iconology* examines the cultural and social ambience from which the work emerged in order to understand why a theme was chosen or why it was represented the way it was.

Scholars have also been considered lately how iconology can be used to elucidate meaning in the artwork, examining its strengths and

challenges. Katharina Lorenz,* for example, argues for the value of art historical methodologies as a tool for the interpretation of ancient art, and applies iconological analysis to three well-known artworks: an Attic red-figure hydria,* a frieze from the Great Altar at Pergamon,* and a Roman sarcophagus.* Serving as an introduction to the use of art-historical theories and methodologies in the study of mythological imagery, her book also highlights iconology's contextualization of an image within a historical framework (e.g. the hydria in the context of Athenian social practices).[14]

NOTES

1 Ralph A. Smith, "'What Is Art History?' Panofsky and the Foundations of Art History, by Michael Ann Holly [Review]," *Studies in Art Education* 28, no. 3 (1987): 179.

2 Svetlana Alpers, *The Art of Describing: Dutch Art in the Seventeenth Century* (Chicago: Chicago University Press, 1983). See also Jonathan Harris, *The New Art History: A Critical Introduction*, (London and New York: Routledge, 2011), 178.

3 Svetlana Alpers, "Is Art History?" *Daedalus* 106, no. 3, Discoveries and Interpretations: Studies in Contemporary Scholarship, Volume I (Summer, 1977), 6.

4 Michael Ann Holly, *Panofsky and the Foundations of Art History* (Ithaca, NY: Cornell University Press 1984), 22.

5 Rensselaer W. Lee, "Erwin Panofsky," *Art Journal* 27, no. 4 (1968): 368.

6 Giulio Carlo Argan and Rebecca West, "Ideology and Iconology," *Critical Inquiry* 2 (Winter 1975): 302–4.

7 Jan Białostocki, "Erwin Panofsky (1892–1968): Thinker, Historian, Human Being," *Simiolus: Netherlands Quarterly for the History of Art* 4, no. 2 (1970): 40.

8 William S. Heckscher, "Erwin Panofsky: A Curriculum Vitae," *Record of the Art Museum, Princeton University* 28, no. 1 (1969): 10.

9 Oskar Bätschmann, *Einf*ührung in die kunstgeschichtliche *Hermeneutik* (Darmstadt: Wissenschaftliche Buchgesellschaft, 1984).

10 See Wendy Steiner, "The Vast Disorder of Objects: Photography and the Demise of Formalist Aesthetics," in *Meaning in the Visual Arts: Views from*

the Outside, ed. Irving Lavin (Princeton: Institute for Advanced Study, 1993).

11 Michael Ann Holly, *Panofsky and the Foundations of Art History* (Ithaca NY: Cornell University Press, 1984), 163–4.

12 See, for instance, Rudolf Wittkower, "Interpretation of Visual Symbols in the Arts," in *Studies in Communication*, ed. Ifor Evans. (London: Secker and Warburg, 1955), 109–24.

13 Horst Bredekamp, "Words, Images, Ellipses," in *Meaning in the Visual Arts: Views from the Outside*, ed. Irving Lavin (Princeton: Institute for Advanced Study, 1993), 363.

14 Katharina Lorenz, *Ancient Mythological Images and their Interpretation: An Introduction to Iconology, Semiotics, and Image Studies in Classical Art History* (Cambridge; New York: Cambridge University Press, 2016).

IMPACT AND INFLUENCE TODAY

KEY POINTS

- The content of visual culture has changed, but some of Panofsky's core ideas presented in *Meaning in the Visual Arts* are still important and influential beyond the boundaries of strict academic inquiry.

- Panofsky's theoretical concepts may not have such fundamental influence on the interdisciplinary pursuits of art-historical research as they have had before.

- Both the historical humanism of the Renaissance itself, and the humanistic foundations of Panofsky's art historical methodology, have been widely rejected in recent decades.

Position

Edwin Panofsky's *Meaning in the Visual Arts* deals with a variety of subjects. Thus, any discussion about the contemporary relevance of this seminal text, or the extent to which it is still challenging or transforming existing ideas, must take into account the most recent reception of Panofsky's thinking as a whole. Overall, while historiography has passed quite unnoticed over most of the humanities in recent decades, attempts to recast earlier scholarship into new approaches to art history have been quite limited. The hostility to humanism embedded in recent theory has also been crucial in distancing art history and the classical tradition. However, as Robert Gaston remarks, visual culture may prove to be one of the disciplines that most actively preserves the classical tradition in the twenty-first century.[1] For example, the concept of iconology could be used to accommodate a wide range of theoretical alternatives

> ❝ In the early 1950s the history of art was an elite subject of no more than dilettantic interest to 'serious' historians in other fields, whereas by now no humanist or social scientist can seem serious if he does not consider visual culture … I believe the change is partly due to the enormous influence of Panofsky. ❞
>
> Willibald Sauerländer, *Meaning in the Visual Arts: Views From The Outside.*

now available. In this respect, it is not difficult to see that the shape of contemporary art history has been permanently altered by various debates in all of the humanities that have enticed scholars to cross many disciplinary boundaries, a pursuit that was successfully pioneered by Panofsky himself.

Social art history,* as it has been carried on by art historians from the 1970s onwards, focuses on the circumstances of the making of an individual work. Matters such as who commissioned an artwork, where it was to be placed, what function it served and for what audience was it intended, came to testify to its very nature as an object. Nowadays, art market value can also determine and affect the aesthetic appreciation of an artifact to a great extent. Moreover, since readers and viewers bring to the images their own cultural experiences, there can be no such thing as a fixed, predetermined, or unified meaning based on the methods developed by some of the most influential figures among the first great generations of modern art historians— such as Wölfflin and Panofsky—who largely concentrated their attention and developed their modes of analysis with reference to the art of the Italian Renaissance.

At the centenary of his birthday in 1992, Panofsky certainly remained very present in the discourse of the discipline, but, arguably, he was no longer the generally admired great master. He had become instead, "a disputed and controversial figure from an unrecoverable

past."[2] Now that "*culture* appears to be a universal solvent for all disciplines, media, and forms of life … Panofsky's clarity of moral, political, and disciplinary purpose seems," as William Mitchell* explains, "residual, archaic, even as its ideological foundations seem not merely dominant, but without significant opposition." Perhaps this shows that an ideology or a theory needs a rival in order to flex its muscles and become alive. This surely, Mitchell continues, "indicates that we occupy a different historical moment, one in which the boundaries and oppositions that could found a 'history of art' have shifted quite drastically."[3]

Interaction

Being at the forefront of theoretical developments and intellectual debates of the decades before and after 1950, Panofsky's approach to the study of art history became hugely influential both in the discipline and beyond. Art historians, archeologists and anthropologists are still faced—and will continue to be so—with the problem of interpreting visual artifacts that have become divorced from the cultural contexts within which they were originally created and that once had a meaning. Therefore, questions such as how, if at all, can we investigate the iconographic themes of cultures that left us with no textual records, never ceases to excite cultural historians, and can only keep bringing Panofsky's modes of interpretation back on track. However, reflecting on the variety of particular problems that confront the contemporary interpreter of the visual arts of the past, as well as on the renewed interest in his contribution to art-historical studies in the late 1980s, Keith Moxey* remarks that "the application of critical strategies to the interpretation of the visual arts of the past … has necessarily called into question Panofsky's 'iconological' method with its concern to understand the work of art within the conceptual framework of the historical period in which it was produced."[4] Moreover, art history is undoubtedly an ongoing academic concern,

yet, the development of new media and forms of mass communication have cast doubt upon the custodianship of the traditional disciplines. Therefore, current intellectual debates do not concern themselves with Panofsky's text to the extent that they did in the 1960s, 1970s, and 1980s when urgent questions about the intellectual coherence of the discipline of art history were being asked. The work of open-minded art historians, such as Meyer Schapiro* who analyzed Romanesque art in the light of abstract painting with fascinating results, may seem more relevant today.

The Continuing Debate

Each essay in Panofsky's *Meaning in the Visual Arts* raises different questions and follows Panofsky's critical approach within various contexts. Therefore, there have been plenty of thinkers across a wide range of debates engaged in explaining, developing, praising, or arguing against his core ideas and art-historical methodology. On one hand, it was Panofsky's humanistic art history that "has been ruthlessly interrogated during the 1980s and 1990s. He has been exposed as neo-Kantian … as a man of his time, generating his methodology in the context of German philosophical, aesthetic and scientific thought in the 1910s and 1920s."[5] On the other hand, one of the challenges of what we generally call today "visual culture" is to generate a system for the study of images so that historians in many fields are able to expand their knowledge about artworks using textual and visual sources, as well as empirical research paradigms; Panofsky's place in these methodological endeavors seem likely to be assured.

According to some scholars, however, the clarity of the third level of Panofsky's analysis (i.e. iconological interpretation) is overtaken by a degree of confusion. How can a work of art communicate the artist's deepest feelings, or the character of the society that surrounds it? Panofsky makes the iconographical judgment that "a group of thirteen men around a dinner table … represents the Last Supper."[6] But, as

Stephen Bann asks, "does it get us much further to suggest that we should then study the artwork as a document of Leonardo's personality, or of the civilization of the Italian High Renaissance, or of a peculiar religious attitude"?[7]

Overall, it was Panofsky's attempt to provide an iconological method of reading and understanding the image of an artwork that triggered debates, attracted much criticism and formed the starting point for later scholars who differed in their approach. Whether art history might prove to be one of the disciplines that will most actively preserve the classical tradition in the twentieth-first century, is a question to be asked. Notwithstanding, Panofsky remains central in any future art history, even one that reaches beyond the specific European traditions studied by him to respond to current interests in the arts, or at least in the comparative study of diverse cultures and their intersections. As if to confirm the lasting importance of Panofsky's ideas and the impact of the latter's scholarship on research in the humanities, a centennial symposium was held at the Institute for Advanced Study in 1993 to commemorate Panofsky's birth. The symposium produced the single most important written work in the post-Panofsky period in the form of its published proceedings.[8] This is due to the fact that the task that the organizers set out for the participants was not to praise once more Panofsky's remarkable scholarly achievements, but instead, to test the stimulating effect that his ideas and cross-cultural explorations beyond the borders of art history might continue to exercise on the humanities and the social sciences at large.

NOTES

1 Robert W. Gaston, "Erwin Panofsky and the Classical Tradition," *International Journal of the Classical Tradition* 4, no. 4 (1998): 622–3.

2 Willibald Sauerländer, "Struggling with a Deconstructed Panofsky," in *Meaning in the Visual Arts: Views from the Outside*, ed. Irving Lavin (Princeton: Institute for Advanced Study, 1993), 386.

3 W. J. T. Mitchell, "What is Visual Culture?" in *Meaning in the Visual Arts: Views from the Outside*, ed. Irving Lavin (Princeton: Institute for Advanced Study, 1993), 216.

4 Keith Moxey, "Panofsky's Concept of 'Iconology' and the Problem of Interpretation in the History of Art, "*New Literary History: A Journal of Theory and Interpretation* 17, no. 2 (Winter 1986): 265–74.

5 Robert W. Gaston, "Erwin Panofsky and the Classical Tradition," 618.

6 Erwin Panofsky, *Meaning in the Visual Arts*, (New York: Doubleday, 1955), 31.

7 Stephen Bann, "Meaning/Interpretation", in *The Art of Art History: A Critical Anthology*, ed. Donald Preziozi (Oxford: Oxford University Press, 2009), 258.

8 Irving Lavin, ed., *Meaning in the Visual Arts: Views from the Outside. A Centennial Commemoration of Erwin Panofsky, 1892–1968* (Princeton: Princeton University Press, 1998).

WHERE NEXT?

KEY POINTS

- *Meaning in the Visual Arts* remains a fertile text for questioning the various meanings of an artwork, and for understanding Panofsky as a revolutionary art-history writer.

- Panofsky's *Meaning in the Visual Arts* is likely to be remembered as a classic, and not be forgotten or be without enduring relevance or appeal.

- More than any other scholar of his generation, Panofsky shaped the methods and the interests of the field, enlarged the perspectives of the discipline and raised art history to a new respected status among the humanities.

Potential

What place does Erwin Panofsky's *Meaning in the Visual Arts* occupy in people's lives today? The text is a valuable collection of essays not only because it brings together old and revised material, but also because it contains some of the most radical and revolutionary of Panofsky's ideas. To an extent, these ideas shaped art history's theoretical framework and achieved international recognition. However, as Holly argued in the mid 1980s, "although art history continues to be practiced at a great rate in institutions throughout the world, and although the curriculum of graduate schools has probably not changed remarkably in the last quarter of the century, the majority of the teachers and scholars of art historical methods are no longer preoccupied with the ultimate questions of *meaning* and *mind* that excited the imaginations of the architects of those methods."[1] Regardless, secure on the foundations laid by prominent

> ❝The skilled historian would use iconology's
> underlying theoretical principles, in turn, to
> comprehend underlying historical principles, to
> penetrate beyond the facts of the work's existence into
> the mood, the desires, the beliefs and the motives of the
> individual and time that created it ... Panofsky would
> agree, iconology can well be thoughtfully applied to any
> cultural achievement, including his own.❞
>
> Michael Ann Holly, *Panofsky and the Foundations of Art History*

scholars, such as Panofsky, art history has continued to develop into a recognized and active discipline today. Panofsky is thus important to the present and has the great potential to be relevant in the future because his lifetime search for underlying meaning in the visual arts, his multi- and cross-disciplinary scope, and his awareness of the necessity for the aesthetic recreation of artistic intentions in various epochs since the Middle Ages and the Renaissance, are still influential and can be further developed. For example, Panofsky's pioneering attempt to provide a philosophy of iconology exerted a great influence on later writers who, in turn, differed from it. Paul Taylor's* attempt to expand on Panofsky's three levels of iconographic interpretation by proposing at least 10 levels of description (including resemblance, depiction, representation, and illustration) is quite characteristic.[2]

Thanks to Panofsky, these critical tools are now available for a wider audience to use. Therefore, the space Panofsky opened for what came to be called *iconology* was not so much the inauguration of an art historical method as it was an attempt to establish discussion of the various meanings of the visual arts within the study of human culture. This approach holds the potential to continually be renewed in relation to new directions and applications. For example,

iconological research can also be undertaken into different modes of artistic expression, such as portraits, landscapes,* or still life, but without consisting of ascertaining who the characters are, or what place, fruit, or flower is represented. Giulio Argan characteristically wrote in the mid 1970s: "The iconology of a portrait is the pose, the dress, the social or psychological meaning which can be attributed to the figure; the iconology of a landscape or of a still life is the mode of perspective, the configurations, the rendering of places and things as significant."[3]

Future Directions

Panofsky is widely regarded as the most universalist and all-embracing of art-historical theorists. Through his public lectures and countless writings, he clearly recognized the need for art history to be interdisciplinary; in other words, to deal with all kinds of art, low-rate art* as well as masterpieces, to encourage theoretical self-reflection, and avoid becoming a merely practical or curatorial profession.

Moreover, Panofsky's corpus (nicely represented in *Meaning in the Visual Arts*) will most probably quicken and nourish the scholarship of the future, endowing it "not only with a vast wealth of learning, but with a method at once subtle and exacting…for achieving new insights into the meaning and significance of works of art and architecture."[4] The translated editions of his numerous books and articles into a great number of languages including French, Spanish, Greek, Italian, Portuguese, Bulgarian, Czech, Hungarian, Russian, Swedish, Finnish, Polish, Hebrew, Japanese, Korean, and Chinese are also an indication of such continuing and enormous impact: "As of 2008, his known editions, reprints, and foreign translations number well more than 300, of which more than half were published posthumously, with requests continuing to come in from throughout the world."[5]

Overall, the problem of what and how and for whom works of art are significant remains an enduring question in academia underlying all approaches to art history as an academic discipline. Therefore, scholars—whether art historians, archeologists, philosophers, or sociologists—will certainly continue to ask questions, such as when and under what conditions (and for whom) is the analysis of an artwork adequate or sufficient?

Summary

Edwin Panofsky's *Meaning in the Visual Arts* contains some of the most influential and pioneering ideas in art-historical scholarship, particularly in the systematic interpretation of the visual arts since the 1920s. Therefore, the nine essays can still be of use to anyone concerned with the theoretical developments of the discipline and of Renaissance art, as well as with the concepts of iconology, iconography, content, meaning, and human proportions. By giving a complete account of his methodological scheme based on three stages of analyzing the meaning or subject matter present in every visual image in a crisp and lively style, the book can still be of great value not only to those interested in the history of the human mind and culture since the Middle Ages and the Renaissance, but to anyone who wishes to become acquainted with the ideas of a remarkable group of scholars who greatly influenced Panofsky's own thinking and methods of research. Panofsky's well-written and stimulating essays, combined with great understanding of his source material, acute judgments and intelligently disposed information, does all this.

The broad display of scholarly interests contained in *Meaning in the Visual Arts*—as in Panofsky's wider work—makes it difficult to define Panofsky's text, but for students of art history and visual studies, this opens up the possibility of thinking of him as a universal scholar, relevant to all ages, places, and cultures.

NOTES

1 Michael Ann Holly, *Panofsky and the Foundations of Art History* (Ithaca NY: Cornell University Press, 1984), 10.

2 Paul Taylor, "Introduction," in *Iconography Without Texts. Warburg Institute Colloquia 13*, ed. Paul Taylor (London & Turin: The Warburg Institute – Nino Aragno Editore, 2008), 1–10.

3 Giulio Carlo Argan and Rebecca West, "Ideology and Iconology," *Critical Inquiry* 2 (Winter 1975): 301.

4 Rensselaer W. Lee, "Erwin Panofsky," *Art Journal* 27, no. 4 (1968): 370.

5 IAS, "Erwin Panofsky's Legacy," accessed November 5, 2017, http://www.ias.edu/people/panofsky/legacy.

GLOSSARY

GLOSSARY OF TERMS

Abitur: (in Germany) refers to the qualification issued after candidates have passed their final exams at the end of their secondary education. This qualification formally enables pupils to attend higher education.

Aesthetics: a branch of philosophy concerned with the evaluation of beauty.

Baroque: a period of artistic style that used exaggerated motion and clear, easily interpreted detail to produce drama, tension, exuberance, and grandeur in sculpture, painting, architecture, literature, dance, theatre, and music. The style began around 1600 in Rome and Italy, and spread to most of Europe.

Classical antiquity: the long period of cultural history centered on the Mediterranean Sea, comprising the interlocking civilizations of ancient Greece and ancient Rome, collectively known as the Greco-Roman world. Conventionally, it begins with Homer (eighth–seventh century B.C.E.), and ends with the dissolution of classical culture at the close of late antiquity (300–600 C.E.).

Classicism: the following of ancient Greek or Roman principles and style in art and literature, generally associated with harmony, restraint, and adherence to recognized standards of form and craftsmanship, especially from the Renaissance to the eighteenth century.

Content: in relation to art, the term refers to a work's essence, or what is being depicted.

Deconstructivism: a movement of postmodern architecture that appeared in the 1980s, which gives the impression of the

fragmentation of the constructed building. It is characterized by an absence of harmony, continuity, or symmetry.

Elegy (elegiac tradition): in literature, an elegy is a poem of serious reflection, typically a lament for the dead. It comes from the Greek word *elegeia* (ἐλεγεία; from ἔλεγος) and originally referred to any verse written in elegiac couplets and covering a wide range of subject matter (death, love, war).

Enlightenment: a period of European history in which many traditional social and political ideas were challenged by rationalistic and skeptical thought. Though there is no definite start or end date, this period is generally associated with the seventeenth and eighteenth centuries.

Epistemology: the branch of philosophy concerned with the theory of knowledge.

Form: in art, "form" can refer to the overall morphology taken by the work—its physical nature—or to the element of "shape" among the various elements that make up an artwork

Formalism: (in art history) commonly refers to an approach to the appreciation and analysis of artifacts privileging their formal or morphological qualities over (or without respect to) other aspects of a work's production, reception, subject-matter, or thematic significance. Panofsky's "iconographic methodology" was a reaction to Wölfflin's formalism.

Gothic art: a style of medieval art that developed in Northern France in the twelfth century C.E., led by the concurrent development of Gothic architecture.

Habilitation: in Germany, the highest academic qualification based on independent scholarship. It come from the Latin word *habilis* (skillful).

Hermeneutics: the theory and practice of interpretation, either of written texts or of verbal and nonverbal forms of communication.

Historiography: the study of the methods of historians in developing history as an academic discipline.

Humanism: a philosophical and ethical stance that emphasizes the value and agency of human beings, both individually and collectively. In the Renaissance, it was a cultural movement that turned away from medieval scholasticism and revived interest in ancient Greek and Roman thought.

Humanities: the study—through philosophy, literature, religion, art, music, history, and language—of how people process and document the human experience.

Hydria: a water-jar with three handles, two for carrying and one for pouring.

Iconography: the study that identifies, describes, classifies, and interprets the content of images. That is, symbols, themes, and subject matter that are distinct from artistic style (the latter refers only to the visual appearance of a work of art which relates it to other works by the same artist). The word *iconography* comes from the Greek εἰκών (an image) and γράφειν (to write). It also refers to the production of religious works of art in the Byzantine and Christian Orthodox tradition.

Iconology: the study of visual imagery and its symbolism and interpretation, especially in social or political terms. It comes from the Greek εἰκών (an image) and λόγος (speech, voice). Panofsky's "iconology" referred to the study of the deeper meanings of artworks. For him, iconology is a method of interpretation that arises from synthesis rather than analysis.

Ideology: a system of beliefs or principles that aspire to explain the world or change it.

Institute for Advanced Study (IAS): founded in 1930, by philanthropist brother and sister Louis and Caroline Bamberger, to encourage and support research in the sciences and humanities, the Institute soon became one of the leading centers for theoretical research and intellectual inquiry in the twentieth-century. Albert Einstein was one of the first in a long line of distinguished scientists and scholars at the Institute.

Joachimsthalsches Gymnasium: a classical grammar school founded in 1607 by the Elector Joachim Friedrich of Brandenburg in the town of Joachimsthal near Berlin, Germany. It was regarded as one of the foremost schools in the German speaking countries.

Kantian: associated, attached, defined, or influenced by German philosopher Immanuel Kant,* 1724–1804.

Kunstwollen: literally translated as "artistic volition" or "will of art" this is the "force" or "will" behind the production of and motivation for art. The term remains one of the most difficult concepts in all of art history.

Landscape painting: one of the principal types or genres of subject in Western art.

Last Supper: the final meal, according to Gospel accounts, that Jesus shared with his Apostles in Jerusalem before his crucifixion. Here, it refers to a late 15th-century mural painting by Leonardo da Vinci housed by the refectory of the Convent of Santa Maria delle Grazie in Milan.

Low-rate art: the opposite of a masterpiece.

Middle Ages: the medieval period in Europe, which lasted from the fifth to the fifteenth centuries. It began with the fall of the Western Roman Empire and merged into the Renaissance.

Medieval art: a period of art history that spans from the fall of the Roman Empire in 300 C.E. to the beginning of the Renaissance around 1400.

Nazism: a totalitarian political movement led by Adolf Hitler, the head of the National Socialist (Nazi) Party, that ruled Germany between 1933 and 1945. Nazism was characterized by its fervent nationalism, dictatorial rule, state control of the economy, military expansion in Europe, and brutal anti-Semitism, which resulted in the systematic extermination of six million Jews during World War II.

Neo-Kantian: a dominant philosophical movement that began in German universities in the 1860s and lasted until the early twentieth century. By its broadest definition, this movement brought Kantian (named after Immanuel Kant*) principles and a terminological framework to bear on a variety of thinkers, as well as on the whole

realm of cultural phenomena. In this sense, diverse thinkers could broadly be considered Neo-Kantian.

Northern Renaissance: the Renaissance that occurred in Europe north of the Alps.

Paidea: (παιδεία) a Greek term for education and culture.

Paradigm: a typical example or pattern of something; a pattern or model.

Pergamon Altar: a monumental construction from the first half of the second century B.C.E. It was built on the acropolis of the ancient Greek city of Pergamon in Asia Minor.

Pietas: (Latin) translated variously as *duty, religiosity* or *religious behavior, loyalty,* or *devotion,* refers to one of the chief virtues among the ancient Romans.

Philology: the literary study of classical languages and other written historical resources. It comes from the Greek terms φίλος [philos] (friend, beloved) and λόγος [logos] (word, reason).

Postmodernism: a movement in the arts emerging after World War II that involves both a continuation as well as a break from the counter-traditional experiments of modernism, which in time had inevitably become conventional. Postmodernism breaks from the elitism of modernist high art by recourse to the models of mass culture in film, television, and architecture.

Privatdozent: the entry-level position conferred by universities in German-speaking countries.

Reception: a branch of modern literary studies concerned with the ways in which literary works are received by readers. In an art context, reception theory refers to the way an audience actively decodes a work of art and helps to define and explore the meaning of the cultures we live in today.

Renaissance: a period in European history, from the fourteenth to the seventeenth centuries, regarded as the cultural bridge between the Middle Ages and modern history.

Sarcophagus: a stone coffin, especially one bearing a sculpture or inscription. It is usually associated with the ancient civilizations of Egypt, Rome, and Greece.

Semiology or semiotics: the study of society's symbols and signs, and of how meaning is created and communicated through these signs. Modern semiotics has its origins in the work of Ferdinand de Saussure.

Social art history: a highly influential movement widely practiced by art historians, particularly during the 1980s and 1990s. Although it assumes less importance today, it still holds some relevance, as it presented a new perspective on looking at art.

Sociology: the scientific study of the development, structure, and functioning of human society.

Structuralism: an intellectual movement of the early twentieth-century. It is characterized by the belief that human culture and societies are governed by underlying patterns and forces that interact in a larger system.

Subjectivism: the doctrine that all knowledge is limited to experiences by the self, and that transcendent knowledge is impossible.

Vulgarian: refers to an unrefined person, especially one with newly acquired power or wealth.

World War I (1914–18): global conflict that began in 1914, pitting the Allies, a group of countries including the United Kingdom, France, and Russia, against the Central Powers, which included Germany, Austria–Hungary, and the Ottoman Empire. The war ended in 1918 with the defeat of the Central Powers.

World War II (1939–45): the most widespread military conflict in history, resulting in more than 50 million casualties. While the conflict began with Germany's invasion of Poland in 1939, it soon involved all of the major world powers, who gradually formed two military alliances and were eventually joined by a great number of the world's nations.

PEOPLE MENTIONED IN THE TEXT

James S. Ackerman (1919–2016) was an American architectural historian, a major scholar of Michelangelo's architecture, of Palladio, and of Italian Renaissance architectural theory.

Svetlana Alpers (b. 1936) is an American art historian and critic. She has been an exponent of the "new art history" and is an expert in Dutch Baroque art. She revolutionized the field with her 1984 book *The Art of Describing*.

Friedrich Antal (1887–1954) was a Jewish Hungarian art historian. He is best known for his contributions to the social history of art.

Giulio Carlo Argan (1909–92) was an Italian art historian. Among the corpus of his work, *Storia dell'Arte Italiana* (1968) was the most influential.

Stephen Bann (b. 1942) is Emeritus Professor of Art History at the University of Bristol. He has been influential in focusing scholarly attention on connections between the history of art and visual culture.

Oscar Bätschmann (b. 1943) is a Swiss art historian. His work focuses on methodological problems of art history and artists such as Leon Battista Alberti and Nicolas Poussin.

Jan Białostocki (1921–88) was one of the most famous Polish art historians of the twentieth century, and Director of the Warsaw Museum of Fine Arts. His research interests were exceptionally broad and included the art of the Renaissance and Baroque.

Sandro Botticelli (Alessandro di Mariano di Vanni Filipepi) (1445–1510) was an Italian painter of the early Renaissance.

Ernst Cassirer (1874–1945) was a German philosopher and one of the leading advocates of twentieth-century philosophical idealism, who gave equal attention to the natural sciences and to the humanities. In his seminal work on the *Philosophy of Symbolic Forms* (1923, 1925, 1929) he attempted to unite scientific and non-scientific modes of thought.

Leonardo da Vinci (1452–1519) was an Italian Renaissance artist and polymath. He is widely considered to be one of the greatest painters of all time.

Albrecht Dürer (1471–1528) was one of the most versatile and gifted German artists of the Renaissance. By expanding its dramatic range and by providing its imagery with new conceptual foundations, technical superiority, and intellectual scope, Dürer revolutionized the medium of printmaking, which subsequently became an independent art form.

Albert Einstein (1879–1955) was a German-born theoretical physicist who developed the theory of relativity. He won the Nobel Prize for Physics in 1921.

Jan Ameling Emmens (1924–71) was a Dutch art historian, and director of the Dutch Institute for Art History in Florence. He was also Professor of Art History and Iconology at Utrecht University.

Michel Foucault (1926–84) was a French critic and philosopher who achieved worldwide fame in the 1960s by paying new attention

to the issue of representation and the variable relationship between linguistic signs and plastic elements in the history of Western art. In his most famous work *Les Mots et les Choses* (*The Order of Things*, 1966), Foucault focused on the relation between words and things from the Renaissance to the modern period including a challenging interpretation of Velasquez's panting *Las Meninas*.

Robert W. Gaston: is Associate Professor and Principal Fellow in Art History at the School of Culture and Communication, University of Melbourne.

Creighton Gilbert (1924–2011) was an American art historian. He is considered one of the most distinguished scholars of Renaissance art history.

Adolf Goldschmidt (1863–1944) was a German art historian specializing in medieval illuminated manuscripts, bronzes, ivories, and stone sculpture.

Richard A. Goldthwaite is professor emeritus of history at the Johns Hopkins University. He is the author of *The Building of Renaissance Florence: An Economic and Social History* and *Wealth and the Demand for Art in Italy, 1300–1600*, both also published by Johns Hopkins.

Ernst Gombrich (1909–2001) was an Austrian-born art historian who spent most of his working life in the United Kingdom. He was the author of *The Story of Art*, a book widely regarded as one of the most accessible introductions to the visual arts.

Joan Hart is an art historian specialist on the writings of Heinrich Wölfflin and Erwin Panofsky.

John Hooper Harvey (1911–97) was an English architectural historian, who specialized in writing on English Gothic architecture and architects.

Francis Haskell (1928–2000) was an English art historian who wrote one of the first and most influential patronage studies of the Baroque era, *Patrons and Painters*.

William S. Heckscher (1904–99) was a German art historian. After studying under Erwin Panofsky at the University of Hamburg, he fled Hitler's Germany and became a professor at Duke University and the director of its art museum.

Georg Wilhelm Friedrich Hegel (1770–1831) was a German philosopher. Art played an important role in his account of history as a mode through which mind comes to know itself.

Michael Ann Holly (b. 1944) is an American art historian who served as the Starr Director of Research and Academic Programs at the Clark Art Institute in Williamstown, Massachusetts before retiring in 2016. She is renowned for her work on historiography and the theory of art history.

Horst Waldemar (H. W.) Janson (1913–82), was a Russian-born art historian of Renaissance sculpture. He is best known for his 1962 *History of Art*, which has sold more than four million copies in fifteen languages.

Immanuel Kant (1724–1804) was a German philosopher and a central figure in modern philosophy. He synthesized early modern rationalism and empiricism, setting the terms for much of nineteenth- and twentieth-century philosophy.

Francis William Kent (1942–2010) was an Australian cultural and social historian of Renaissance Florence.

Paul Oskar Kristeller (1905–99) was a German scholar of Renaissance humanism. He was last active as Professor Emeritus of Philosophy at Columbia University in New York.

Rensselaer W. Lee (1898–1984) was an American art historian who specialized in Baroque and art theory. He put emphasis on how philosophical and aesthetic theory could shape the production of art in the Renaissance and Baroque eras.

Katharina Lorenz is Professor of Classical Art and Archaeology at the University of Nottingham. Her work ranges across the fields of Greek and Roman art and archeology.

Thomas Mann (1875–1955) was a German novelist known for his novels *Buddenbrooks* (1901) and *The Magic Mountain* (1924). He won the Nobel Prize for Literature in 1929.

Karl Mannheim (1893–1947): was a Hungarian-born sociologist, best known for his book *Ideology and Utopia* published in 1929

Michelangelo di Lodovico Buonarroti Simoni (1475–1564) was an Italian sculptor, painter, architect, and poet of the High Renaissance born in the Republic of Florence, who exerted an unparalleled influence on the development of Western Art. Considered to be the greatest living artist during his lifetime, he has since been described as one of the greatest artists of all time.

William John Thomas (W. J. T.) Mitchell (b. 1942) is the Gaylord Donnelley Distinguished Service Professor of English and Art History

at the University of Chicago. He works particularly on the history and theories of media, visual art, and literature, from the eighteenth century to the present, exploring the relations of visual and verbal representations in the culture and iconology.

Keith Moxey (b. 1943) is Barbara Novak Professor of Art History at Barnard College. He is the author of books on the historiography and philosophy of art history, as well as on sixteenth-century painting and prints in Northern Europe.

J. Robert Oppenheimer (1904–67) was an American theoretical physicist best known for his involvement in the American nuclear-weapons program.

Otto Pächt (1902–88) was an Austrian art historian who emigrated to England due to the Nazi racial laws. He was an expert in medieval manuscripts, early Netherlandish painting, and art-historical methods.

Michael Podro (1931–2008) was a British art historian. He is best known for *The Manifold in Perception: Theories of Art from Kant to Hildebrand* (1972), and *Critical Historians of Art* (1982), where he argued for bringing philosophical questions to bear on the study of art, as well as the prevailing focus on style, attribution, and contextual detail.

Polyclitus (or Polykleitos) was one of the most important sculptors of Classical antiquity.

Nicolas Poussin (1594–1665) was the leading painter of the classical French Baroque style, who brought a new intellectual rigor to the classical impulse in art. He spent most of his working life in Rome, and most of his works were on religious and mythological subjects painted for a small group of Italian and French collectors.

Alois Riegl (1858–1905) was an Austrian art historian. In one of his most important works, *Stilfragen: Grundlagen zu einer Geschichte der Ornamentik* (1893), Riegl traced the development of plant motifs in antique ornament and therefore introduced the concept of artistic intention (*Kunstwollen*), which also represented a turning point in the historiography of art.

Friedrich "Fritz" Saxl (1890–1948) was a Courtauld Institute (London) professor and librarian. He was instrumental in moving the Warburg Library to London and administering it during Aby Warburg's mental illness.

Scipio (Publius Cornelius Scipio Africanus) (236–183 B.C.E.), was a Roman general and later consul who is often regarded as one of the greatest generals and military strategists of all time.

Meyer Schapiro (1904–96) was a Lithuanian-born American art historian known for forging new art historical methodologies that incorporated an interdisciplinary approach to the study of works of art. Shapiro believed that all art must be appreciated within a specific context, and that any great art is linked to the social and economic conditions of its time.

Gary Schwartz (b. 1940) is an American art historian specialized in the art of Rembrandt and Dutch Golden Age paintings and prints.

Randolph Starn is emeritus professor of History and Italian Studies at Berkeley.

Roelof van Straten is a Dutch art historian. He the author of numerous articles and a four-volume reference work on Italian prints.

Claude Lévi-Strauss (1908–2009) was a French ethnologist and anthropologist. He is frequently cited as the father of modern anthropology.

Abbot Suger (c.1081–1151) ranks with the major figures of European political and architectural history. As abbot of the French Abbey of Saint-Denis, Suger, he became a very influential counsellor to Kings Louis VI and VII. Between 1137 and 1144, he supervised the rebuilding of the Royal Abbey Church of Saint-Denis outside Paris. The new structure is often cited as the prototype for Gothic architecture.

Paul Taylor is the Curator of the Photographic Collection, and one of the art history editors of the *Journal of the Warburg and Courtauld Institutes*.

Bernard Teyssèdre (b. 1930) is a French philosopher and writer. He has written extensively in a variety of fields ranging from literary creation to aesthetic theory and art history.

Titian (Tiziano Vecellio) (c.1490–1576) was one of the greatest painters of sixteenth-century Venice, and one of the very first to have an international clientele. Working with portraits and public religious paintings of various Italian courts, he became famous and in demand at courts across Europe.

Richard Trexler (1932–2007) was an American professor of History at the Binghamton University, State University of New York. He was a specialist on the Renaissance, the Reformation of Italy and Behaviorist history.

Giorgio Vasari (1511–74) was an Italian painter, architect, writer, and historian. He is well known for his *Lives of the Most Excellent Painters, Sculptors, and Architects*—a work that is considered the ideological foundation of art-historical writing.

Marcus Vitruvius (c. 80/70–after 15 B.C.E.) was a Roman architect, author and engineer. His best-known work, a treatise on architecture (*De Architectura*), is one of the most important sources of knowledge of Roman building methods and design.

Wilhelm Vöge (1868–1952) was an influential art historian who specialized in the stylistic analysis of medieval art. In 1894 he published his important work on French medieval sculpture (*Die Anfänge des Monumentalen Stiles im Mittelalter*) designating the transition from the Romanesque to the Gothic and became Professor of Art History at the Albert-Ludwigs-Universität in Freiburg in 1908.

Aby Warburg (1866–1929) was the founder of the Kulturwissenschaftliche Bibliothek Warburg, a private library for cultural studies focused on the legacy and reception of the classical world by Western culture. This was later known as the Warburg Institute.

Rudolf Wittkower (1901–71) was a German-American art historian. His most important works are on seventeenth-century Italian art and architecture, the sculptor Lorenzo Bernini, the architect Francesco Borromini, and the draftsmanship of the Carracci family.

Heinrich Wölfflin (1864–1945) was one of the most influential and popular art historians in Switzerland and Germany, whose classifying principles on form and style were instrumental in the development of art history in the decades before and after 1900. His greatest works,

Renaissance und Barock (1888), *Die Klassische Kunst* (1898) and *Kunstgeschichtliche Grundbegriffe* ("Principles of Art History," 1915) are still consulted today.

Frank Lloyd Wright (1867–1959) was a very influential American architect and interior designer.

WORKS CITED

WORKS CITED

Ackerman, James S. "Renaissance and Renascences in Western Art [Review]." *The Journal of Aesthetics and Art Criticism* 19, no. 3 (1961): 350–51.

Alpers, Svetlana. "Is Art History?" *Daedalus* 106, no. 3, Discoveries and Interpretations: Studies in Contemporary Scholarship, Volume I (Summer, 1977): 1–13.

The Art of Describing: Dutch Art in the Seventeenth Century. Chicago: Chicago University Press, 1983.

Argan, Giulio Carlo, and Rebecca West. "Ideology and Iconology." *Critical Inquiry* 2 (Winter 1975): 297–305.

Bann, Stephen. "Panofsky and the Foundations of Art History, by Michael Ann Holly [Review]." *History and Theory* 25, no. 2 (1986): 199–205.

"Meaning/Interpretation." In *The Art of Art History: A Critical Anthology*, edited by Donald Preziozi, 256–268. Oxford: Oxford University Press, 2009.

Bätschmann, Oskar. *Einführung in die kunstgesichtliche Hermeneutik.* Darmstadt: Wissenschaftliche Buchgesellschaft, 1984.

Białostocki, Jan. "Erwin Panofsky (1892–1968): Thinker, Historian, Human Being." *Simiolus: Netherlands Quarterly for the History of Art* 4, no. 2 (1970): 68–89.

Bredekamp, Horst. "Words, Images, Ellipses." In *Meaning in the Visual Arts: Views from the Outside*, edited Irving Lavin, 363–371, Princeton: Institute for Advanced Study, 1993.

Conant, Kenneth John. "Abbot Suger on the Abbey Church of St.-Denis and Its Art Treasures [Review]." *Speculum* 28, no. 3 (1953): 603–5.

Elsner, Jas, and Katharina Lorenz. "The Genesis of Iconology." *Critical Inquiry* 38.3 (Spring 2012): 483–512.

Emmens, Jan Ameling, and Gary Schwartz. "Erwin Panofsky as a Humanist." *Simiolus: Netherlands Quarterly for the History of Art* 2, no. 3 (1967–8): 109–13.

Gaston, W. Robert. "Erwin Panofsky and the Classical Tradition." *International Journal of the Classical Tradition* 4, no. 4 (1998): 613–23.

Gombrich, Ernst H. "Erwin Panofsky." *The Burlington Magazine* 110.783 (June 1968): 356, 359–60.

Grafton, Anthony. "Panofsky, Alberti and the ancient World." In *Meaning in the Visual Arts: Views from the Outside*, edited by Irving Lavin, 123–130. Princeton: Institute for Advanced Study, 1993.

Harris, Jonathan. *The New Art History: A Critical Introduction*. London and New York: Routledge, 2011.

Hart, Joan. "Erwin Panofsky and Karl Mannheim: A Dialogue on Interpretation." *Critical Inquiry*, 19, no. 3 (Spring 1993): 565.

Harvey, John H. "Abbot Suger on the Abbey Church of St.-Denis and Its Art Treasures [Review]." *The Burlington Magazine* 89, no. 537 (1947): 348.

Haskell, Francis. *Patrons and Painters: A Study in the Relations between Italian Art and Society in the Age of the Baroque*. New York: Alfred A. Knopf, 1963.

Heckscher, William S. "Erwin Panofsky: A Curriculum Vitae." *Record of the Art Museum, Princeton University* 28, no. 1 (1969): 5–21.

Holly, Michael Ann. *Panofsky and the Foundations of Art History*. Ithaca, NY: Cornell University Press 1984.

IAS. "Erwin Panofsky's Legacy." http://www.ias.edu/people/panofsky/legacy.

Janson, H. W. "Erwin Panofsky." *Biographical Memoirs in American Philosophical Society Yearbook 1969–70*.

Knowles, M. D. "Abbot Suger on the Abbey Church of St.-Denis and its Art Treasures [Review]." *The English Historical Review* 63, no. 257 (1948): 236–7.

Kristeller, Paul Oscar. "Renaissance and Renascences in Western Art, by Erwin Panofsky [Review]." *The Art Bulletin* 44, no. 1 (1962): 65–7.

Landauer, Carl. "Erwin Panofsky and the Renascence of the Renaissance." *Renaissance Quarterly* 47.2 (1994): 255–81.

Larsen, Michael. "Meaning in the Visual Arts, by Erwin Panofsky [Review]." *Journal of the Royal Society of Arts* 132, no. 5335 (1984): 477–8.

Lavin, Irving, ed. *Meaning in the Visual Arts: Views from the Outside. A Centennial Commemoration of Erwin Panofsky, 1892-1968*. Princeton: Princeton University Press, 1998.

"Panofsky's History of Art." In *Meaning in the Visual Arts: Views from the Outside*, edited by Irving Lavin, 3–8. Princeton: Institute for Advanced Study, 1993.

Lee, Rensselaer W. "Erwin Panofsky." *Art Journal* 27, no. 4 (1968): 368–70.

Levin, Thomas Y. "Iconology at the Movies: Panofsky's Film Theory." *The Yale Journal of Criticism* 9.1 (1996): 27–55.

Levine, Emily J. "The Other Weimar: The Warburg Circle as Hamburg School." *The Journal of the History of Ideas* 74, no. 2 (2013): 307–30.

Lorenz, Katharina. *Ancient Mythological Images and their Interpretation: An Introduction to Iconology, Semiotics, and Image Studies in Classical Art History*. Cambridge; New York: Cambridge University Press, 2016.

Martin, John Rupert. "Meaning in the Visual Arts, by Erwin Panofsky [Review]." *The Art Bulletin* 40, no. 2 (1958): 159.

Mitchell, W. J. T. "What is Visual Culture?" In *Meaning in the Visual Arts: Views from the Outside*, edited by Irving Lavin, 207–217. Princeton: Institute for Advanced Study, 1993.

Moxey, Keith. "Panofsky's Concept of 'Iconology' and the Problem of Interpretation in the History of Art." *New Literary History: A Journal of Theory and Interpretation* 17, no. 2 (Interpretation and Culture) (Winter 1986): 265–74.

Pächt, Otto. *The Practice of Art History: Reflections on Method*. 1st English edn. London: Harvey Miller, 1999.

Panofsky, Erwin. *Abbot Suger on the Abbey Church of St.-Denis and its Art Treasures*. Princeton: Princeton University Press, 1946.

Albrecht Dürer. Princeton: Princeton University Press, 1943.

"*Das Erste Blatt Aus Dem 'Libro' Giorgio Vasaris: Eine Studie Über Der Beurteilung Der Gotik in Der Italienischen Renaissance Mit Einem Exkurs Über Zwei Fassadenprojekte Domenico Beccafumis*." *Städel-Jahrbuch* 6 (1930): 25–72.

"Die Entwicklung der Proportionslehre als Abbild der Stilentwicklung." *Monatshefte für Kunstwissenschaft* 14 (1921): 188–219.

Die Theoretische Kunstlehre Albrecht Dürers. Berlin: Druck von G. Heimer, 1914–15.

"Dürers Stellung zur Antike." *Jahrbuch für Kunstgeschichte* 1 (1921–2): 43–92.

"*Et in Arcadia Ego*: On the Conception of Transience in Poussin and Watteau." In *Philosophy and History: Essays Presented to Ernst Cassirer*, edited by Raymond Klibansky and Herbert James Paton. 223–54. Oxford: Clarendon Press, 1936.

Hercules am Scheidewege und andere Antike Bildstoffe in der Neueren Kunst. Studien der Bibliothek Warburg, vol. 18. Leipzig and Berlin: B. G. Teubner, 1930.

"The History of Art." in the *Cultural Migration: The European Scholar in America*, edited by W. Rex Crawford and Franz Leopold Neumann. 82–111. Philadelphia: University of Pennsylvania Press, 1953.

"The History of Art as a Humanistic Discipline." In *The Meaning of the Humanities*, edited by Theodore Meyer Greene, 89–118. Princeton and Oxford: Princeton University Press and H. Milford/Oxford University Press, 1940.

Idea: A Concept in Art Theory [English trans.]. Edited by Peake J. S. Columbia, SC: University of South Carolina Press, 1968.

"A Late-Antique Religious Symbol in Works by Holbein and Titian." *Burlington Magazine* 49 (1926): 177–81.

Meaning in the Visual Arts. Garden City, NY: Anchor Books, 1955.

Meaning in the Visual Arts. Chicago: Chicago University Press, 1982.

Studies in Iconology: Humanistic Themes in the Art of the Renaissance. New York: Oxford University Press, 1939.

"Style and Motion in the Motion Pictures." *Critique* 1, no. 3 (1947): 151–69.

Podro, Michael. *The Critical Historians of Art*. New Haven and London: Yale University Press, 1982.

Sauerländer, Willibald. "Struggling with a Deconstructed Panofsky." In *Meaning in the Visual Arts: Views from the Outside*, edited Irving Lavin, 385–396. Princeton: Institute for Advanced Study, 1993.

Smith, Ralph A. "'What Is Art History?' Panofsky and the Foundations of Art History, by Michael Ann Holly [Review]." *Studies in Art Education* 28, no. 3 (1987): 176–81.

Starn, Randolph. "Pleasure in the Visual Arts." In *Meaning in the Visual Arts: Views from the Outside*, edited by Irving Lavin, 151–162, Princeton: Institute for Advanced Study, 1993.

Straten, Roelof van. *An Introduction to Iconography: Symbols, Allusions and Meaning in the Visual Arts*. Translated by Patricia de Man. Amsterdam: Gordon and Breach, 1994.

Steiner, Wendy. "The Vast Disorder of Objects: Photography and the Demise of Formalist Aesthetics." In *Meaning in the Visual Arts: Views from the Outside*, edited by Irving Lavin, 195–205. Princeton: Institute for Advanced Study, 1995.

Taylor, Paul. "Introduction." In *Iconography without Texts*, edited by Paul Taylor. Warburg Institute Colloquia 13, 1–10. London: The Warburg Institute, 2008.

Trapp, Joseph Burney. "The Letters of Erwin Panofsky Korrespondenz 1910 Bis 1968: Eine Kommentierte Auswahl in Fünf Bänden." *International Journal of the Classical Tradition* 11, no. 2 (2004): 280–92.

Wittkower, Rudolf. "Interpretation of Visual Symbols in the Arts." In *Studies in Communication*, edited by Ifor Evans. 109–24. London: Secker and Warburg, 1955.

Wuttke, Dieter, ed. *Erwin Panofsky: Korrespondenz 1910 bis 1968: Eine Kommentierte Auswahl in fünf Bänden*. 5 vols. Wiesbaden: Harrassowitz Verlag, 2001–11.

THE MACAT LIBRARY
BY DISCIPLINE

AFRICANA STUDIES

Chinua Achebe's *An Image of Africa: Racism in Conrad's Heart of Darkness*
W. E. B. Du Bois's *The Souls of Black Folk*
Zora Neale Huston's *Characteristics of Negro Expression*
Martin Luther King Jr's *Why We Can't Wait*
Toni Morrison's *Playing in the Dark: Whiteness in the American Literary Imagination*

ANTHROPOLOGY

Arjun Appadurai's *Modernity at Large: Cultural Dimensions of Globalisation*
Philippe Ariès's *Centuries of Childhood*
Franz Boas's *Race, Language and Culture*
Kim Chan & Renée Mauborgne's *Blue Ocean Strategy*
Jared Diamond's *Guns, Germs & Steel: the Fate of Human Societies*
Jared Diamond's *Collapse: How Societies Choose to Fail or Survive*
E. E. Evans-Pritchard's *Witchcraft, Oracles and Magic Among the Azande*
James Ferguson's *The Anti-Politics Machine*
Clifford Geertz's *The Interpretation of Cultures*
David Graeber's *Debt: the First 5000 Years*
Karen Ho's *Liquidated: An Ethnography of Wall Street*
Geert Hofstede's *Culture's Consequences: Comparing Values, Behaviors, Institutes and Organizations across Nations*
Claude Lévi-Strauss's *Structural Anthropology*
Jay Macleod's *Ain't No Makin' It: Aspirations and Attainment in a Low-Income Neighborhood*
Saba Mahmood's *The Politics of Piety: The Islamic Revival and the Feminist Subjec*t
Marcel Mauss's *The Gift*

BUSINESS

Jean Lave & Etienne Wenger's *Situated Learning*
Theodore Levitt's *Marketing Myopia*
Burton G. Malkiel's *A Random Walk Down Wall Street*
Douglas McGregor's *The Human Side of Enterprise*
Michael Porter's *Competitive Strategy: Creating and Sustaining Superior Performance*
John Kotter's *Leading Change*
C. K. Prahalad & Gary Hamel's *The Core Competence of the Corporation*

CRIMINOLOGY

Michelle Alexander's *The New Jim Crow: Mass Incarceration in the Age of Colorblindness*
Michael R. Gottfredson & Travis Hirschi's *A General Theory of Crime*
Richard Herrnstein & Charles A. Murray's *The Bell Curve: Intelligence and Class Structure in American Life*
Elizabeth Loftus's *Eyewitness Testimony*
Jay Macleod's *Ain't No Makin' It: Aspirations and Attainment in a Low-Income Neighborhood*
Philip Zimbardo's *The Lucifer Effect*

ECONOMICS

Janet Abu-Lughod's *Before European Hegemony*
Ha-Joon Chang's *Kicking Away the Ladder*
David Brion Davis's *The Problem of Slavery in the Age of Revolution*
Milton Friedman's *The Role of Monetary Policy*
Milton Friedman's *Capitalism and Freedom*
David Graeber's *Debt: the First 5000 Years*
Friedrich Hayek's *The Road to Serfdom*
Karen Ho's *Liquidated: An Ethnography of Wall Street*

John Maynard Keynes's *The General Theory of Employment, Interest and Money*
Charles P. Kindleberger's *Manias, Panics and Crashes*
Robert Lucas's *Why Doesn't Capital Flow from Rich to Poor Countries?*
Burton G. Malkiel's *A Random Walk Down Wall Street*
Thomas Robert Malthus's *An Essay on the Principle of Population*
Karl Marx's *Capital*
Thomas Piketty's *Capital in the Twenty-First Century*
Amartya Sen's *Development as Freedom*
Adam Smith's *The Wealth of Nations*
Nassim Nicholas Taleb's *The Black Swan: The Impact of the Highly Improbable*
Amos Tversky's & Daniel Kahneman's *Judgment under Uncertainty: Heuristics and Biases*
Mahbub Ul Haq's *Reflections on Human Development*
Max Weber's *The Protestant Ethic and the Spirit of Capitalism*

FEMINISM AND GENDER STUDIES

Judith Butler's *Gender Trouble*
Simone De Beauvoir's *The Second Sex*
Michel Foucault's *History of Sexuality*
Betty Friedan's *The Feminine Mystique*
Saba Mahmood's *The Politics of Piety: The Islamic Revival and the Feminist Subject*
Joan Wallach Scott's *Gender and the Politics of History*
Mary Wollstonecraft's *A Vindication of the Rights of Woman*
Virginia Woolf's *A Room of One's Own*

GEOGRAPHY

The Brundtland Report's *Our Common Future*
Rachel Carson's *Silent Spring*
Charles Darwin's *On the Origin of Species*
James Ferguson's *The Anti-Politics Machine*
Jane Jacobs's *The Death and Life of Great American Cities*
James Lovelock's *Gaia: A New Look at Life on Earth*
Amartya Sen's *Development as Freedom*
Mathis Wackernagel & William Rees's *Our Ecological Footprint*

HISTORY

Janet Abu-Lughod's *Before European Hegemony*
Benedict Anderson's *Imagined Communities*
Bernard Bailyn's *The Ideological Origins of the American Revolution*
Hanna Batatu's *The Old Social Classes And The Revolutionary Movements Of Iraq*
Christopher Browning's *Ordinary Men: Reserve Police Batallion 101 and the Final Solution in Poland*
Edmund Burke's *Reflections on the Revolution in France*
William Cronon's *Nature's Metropolis: Chicago And The Great West*
Alfred W. Crosby's *The Columbian Exchange*
Hamid Dabashi's *Iran: A People Interrupted*
David Brion Davis's *The Problem of Slavery in the Age of Revolution*
Nathalie Zemon Davis's *The Return of Martin Guerre*
Jared Diamond's *Guns, Germs & Steel: the Fate of Human Societies*
Frank Dikotter's *Mao's Great Famine*
John W Dower's *War Without Mercy: Race And Power In The Pacific War*
W. E. B. Du Bois's *The Souls of Black Folk*
Richard J. Evans's *In Defence of History*
Lucien Febvre's *The Problem of Unbelief in the 16th Century*
Sheila Fitzpatrick's *Everyday Stalinism*

Eric Foner's *Reconstruction: America's Unfinished Revolution, 1863-1877*
Michel Foucault's *Discipline and Punish*
Michel Foucault's *History of Sexuality*
Francis Fukuyama's *The End of History and the Last Man*
John Lewis Gaddis's *We Now Know: Rethinking Cold War History*
Ernest Gellner's *Nations and Nationalism*
Eugene Genovese's *Roll, Jordan, Roll: The World the Slaves Made*
Carlo Ginzburg's *The Night Battles*
Daniel Goldhagen's *Hitler's Willing Executioners*
Jack Goldstone's *Revolution and Rebellion in the Early Modern World*
Antonio Gramsci's *The Prison Notebooks*
Alexander Hamilton, John Jay & James Madison's *The Federalist Papers*
Christopher Hill's *The World Turned Upside Down*
Carole Hillenbrand's *The Crusades: Islamic Perspectives*
Thomas Hobbes's *Leviathan*
Eric Hobsbawm's *The Age Of Revolution*
John A. Hobson's *Imperialism: A Study*
Albert Hourani's *History of the Arab Peoples*
Samuel P. Huntington's *The Clash of Civilizations and the Remaking of World Order*
C. L. R. James's *The Black Jacobins*
Tony Judt's *Postwar: A History of Europe Since 1945*
Ernst Kantorowicz's *The King's Two Bodies: A Study in Medieval Political Theology*
Paul Kennedy's *The Rise and Fall of the Great Powers*
Ian Kershaw's *The "Hitler Myth": Image and Reality in the Third Reich*
John Maynard Keynes's *The General Theory of Employment, Interest and Money*
Charles P. Kindleberger's *Manias, Panics and Crashes*
Martin Luther King Jr's *Why We Can't Wait*
Henry Kissinger's *World Order: Reflections on the Character of Nations and the Course of History*
Thomas Kuhn's *The Structure of Scientific Revolutions*
Georges Lefebvre's *The Coming of the French Revolution*
John Locke's *Two Treatises of Government*
Niccolò Machiavelli's *The Prince*
Thomas Robert Malthus's *An Essay on the Principle of Population*
Mahmood Mamdani's *Citizen and Subject: Contemporary Africa And The Legacy Of Late Colonialism*
Karl Marx's *Capital*
Stanley Milgram's *Obedience to Authority*
John Stuart Mill's *On Liberty*
Thomas Paine's *Common Sense*
Thomas Paine's *Rights of Man*
Geoffrey Parker's *Global Crisis: War, Climate Change and Catastrophe in the Seventeenth Century*
Jonathan Riley-Smith's *The First Crusade and the Idea of Crusading*
Jean-Jacques Rousseau's *The Social Contract*
Joan Wallach Scott's *Gender and the Politics of History*
Theda Skocpol's *States and Social Revolutions*
Adam Smith's *The Wealth of Nations*
Timothy Snyder's *Bloodlands: Europe Between Hitler and Stalin*
Sun Tzu's *The Art of War*
Keith Thomas's *Religion and the Decline of Magic*
Thucydides's *The History of the Peloponnesian War*
Frederick Jackson Turner's *The Significance of the Frontier in American History*
Odd Arne Westad's *The Global Cold War: Third World Interventions And The Making Of Our Times*

The Macat Library By Discipline

LITERATURE

Chinua Achebe's *An Image of Africa: Racism in Conrad's Heart of Darkness*
Roland Barthes's *Mythologies*
Homi K. Bhabha's *The Location of Culture*
Judith Butler's *Gender Trouble*
Simone De Beauvoir's *The Second Sex*
Ferdinand De Saussure's *Course in General Linguistics*
T. S. Eliot's *The Sacred Wood: Essays on Poetry and Criticism*
Zora Neale Huston's *Characteristics of Negro Expression*
Toni Morrison's *Playing in the Dark: Whiteness in the American Literary Imagination*
Edward Said's *Orientalism*
Gayatri Chakravorty Spivak's *Can the Subaltern Speak?*
Mary Wollstonecraft's *A Vindication of the Rights of Women*
Virginia Woolf's *A Room of One's Own*

PHILOSOPHY

Elizabeth Anscombe's *Modern Moral Philosophy*
Hannah Arendt's *The Human Condition*
Aristotle's *Metaphysics*
Aristotle's *Nicomachean Ethics*
Edmund Gettier's *Is Justified True Belief Knowledge?*
Georg Wilhelm Friedrich Hegel's *Phenomenology of Spirit*
David Hume's *Dialogues Concerning Natural Religion*
David Hume's *The Enquiry for Human Understanding*
Immanuel Kant's *Religion within the Boundaries of Mere Reason*
Immanuel Kant's *Critique of Pure Reason*
Søren Kierkegaard's *The Sickness Unto Death*
Søren Kierkegaard's *Fear and Trembling*
C. S. Lewis's *The Abolition of Man*
Alasdair MacIntyre's *After Virtue*
Marcus Aurelius's *Meditations*
Friedrich Nietzsche's *On the Genealogy of Morality*
Friedrich Nietzsche's *Beyond Good and Evil*
Plato's *Republic*
Plato's *Symposium*
Jean-Jacques Rousseau's *The Social Contract*
Gilbert Ryle's *The Concept of Mind*
Baruch Spinoza's *Ethics*
Sun Tzu's *The Art of War*
Ludwig Wittgenstein's *Philosophical Investigations*

POLITICS

Benedict Anderson's *Imagined Communities*
Aristotle's *Politics*
Bernard Bailyn's *The Ideological Origins of the American Revolution*
Edmund Burke's *Reflections on the Revolution in France*
John C. Calhoun's *A Disquisition on Government*
Ha-Joon Chang's *Kicking Away the Ladder*
Hamid Dabashi's *Iran: A People Interrupted*
Hamid Dabashi's *Theology of Discontent: The Ideological Foundation of the Islamic Revolution in Iran*
Robert Dahl's *Democracy and its Critics*
Robert Dahl's *Who Governs?*
David Brion Davis's *The Problem of Slavery in the Age of Revolution*

Alexis De Tocqueville's *Democracy in America*
James Ferguson's *The Anti-Politics Machine*
Frank Dikotter's *Mao's Great Famine*
Sheila Fitzpatrick's *Everyday Stalinism*
Eric Foner's *Reconstruction: America's Unfinished Revolution, 1863-1877*
Milton Friedman's *Capitalism and Freedom*
Francis Fukuyama's *The End of History and the Last Man*
John Lewis Gaddis's *We Now Know: Rethinking Cold War History*
Ernest Gellner's *Nations and Nationalism*
David Graeber's *Debt: the First 5000 Years*
Antonio Gramsci's *The Prison Notebooks*
Alexander Hamilton, John Jay & James Madison's *The Federalist Papers*
Friedrich Hayek's *The Road to Serfdom*
Christopher Hill's *The World Turned Upside Down*
Thomas Hobbes's *Leviathan*
John A. Hobson's *Imperialism: A Study*
Samuel P. Huntington's *The Clash of Civilizations and the Remaking of World Order*
Tony Judt's *Postwar: A History of Europe Since 1945*
David C. Kang's *China Rising: Peace, Power and Order in East Asia*
Paul Kennedy's *The Rise and Fall of Great Powers*
Robert Keohane's *After Hegemony*
Martin Luther King Jr.'s *Why We Can't Wait*
Henry Kissinger's *World Order: Reflections on the Character of Nations and the Course of History*
John Locke's *Two Treatises of Government*
Niccolò Machiavelli's *The Prince*
Thomas Robert Malthus's *An Essay on the Principle of Population*
Mahmood Mamdani's *Citizen and Subject: Contemporary Africa And The Legacy Of Late Colonialism*
Karl Marx's *Capital*
John Stuart Mill's *On Liberty*
John Stuart Mill's *Utilitarianism*
Hans Morgenthau's *Politics Among Nations*
Thomas Paine's *Common Sense*
Thomas Paine's *Rights of Man*
Thomas Piketty's *Capital in the Twenty-First Century*
Robert D. Putman's *Bowling Alone*
John Rawls's *Theory of Justice*
Jean-Jacques Rousseau's *The Social Contract*
Theda Skocpol's *States and Social Revolutions*
Adam Smith's *The Wealth of Nations*
Sun Tzu's *The Art of War*
Henry David Thoreau's *Civil Disobedience*
Thucydides's *The History of the Peloponnesian War*
Kenneth Waltz's *Theory of International Politics*
Max Weber's *Politics as a Vocation*
Odd Arne Westad's *The Global Cold War: Third World Interventions And The Making Of Our Times*

POSTCOLONIAL STUDIES

Roland Barthes's *Mythologies*
Frantz Fanon's *Black Skin, White Masks*
Homi K. Bhabha's *The Location of Culture*
Gustavo Gutiérrez's *A Theology of Liberation*
Edward Said's *Orientalism*
Gayatri Chakravorty Spivak's *Can the Subaltern Speak?*

PSYCHOLOGY

Gordon Allport's *The Nature of Prejudice*
Alan Baddeley & Graham Hitch's *Aggression: A Social Learning Analysis*
Albert Bandura's *Aggression: A Social Learning Analysis*
Leon Festinger's *A Theory of Cognitive Dissonance*
Sigmund Freud's *The Interpretation of Dreams*
Betty Friedan's *The Feminine Mystique*
Michael R. Gottfredson & Travis Hirschi's *A General Theory of Crime*
Eric Hoffer's *The True Believer: Thoughts on the Nature of Mass Movements*
William James's *Principles of Psychology*
Elizabeth Loftus's *Eyewitness Testimony*
A. H. Maslow's *A Theory of Human Motivation*
Stanley Milgram's *Obedience to Authority*
Steven Pinker's *The Better Angels of Our Nature*
Oliver Sacks's *The Man Who Mistook His Wife For a Hat*
Richard Thaler & Cass Sunstein's *Nudge: Improving Decisions About Health, Wealth and Happiness*
Amos Tversky's *Judgment under Uncertainty: Heuristics and Biases*
Philip Zimbardo's *The Lucifer Effect*

SCIENCE

Rachel Carson's *Silent Spring*
William Cronon's *Nature's Metropolis: Chicago And The Great West*
Alfred W. Crosby's *The Columbian Exchange*
Charles Darwin's *On the Origin of Species*
Richard Dawkin's *The Selfish Gene*
Thomas Kuhn's *The Structure of Scientific Revolutions*
Geoffrey Parker's *Global Crisis: War, Climate Change and Catastrophe in the Seventeenth Century*
Mathis Wackernagel & William Rees's *Our Ecological Footprint*

SOCIOLOGY

Michelle Alexander's *The New Jim Crow: Mass Incarceration in the Age of Colorblindness*
Gordon Allport's *The Nature of Prejudice*
Albert Bandura's *Aggression: A Social Learning Analysis*
Hanna Batatu's *The Old Social Classes And The Revolutionary Movements Of Iraq*
Ha-Joon Chang's *Kicking Away the Ladder*
W. E. B. Du Bois's *The Souls of Black Folk*
Émile Durkheim's *On Suicide*
Frantz Fanon's *Black Skin, White Masks*
Frantz Fanon's *The Wretched of the Earth*
Eric Foner's *Reconstruction: America's Unfinished Revolution, 1863-1877*
Eugene Genovese's *Roll, Jordan, Roll: The World the Slaves Made*
Jack Goldstone's *Revolution and Rebellion in the Early Modern World*
Antonio Gramsci's *The Prison Notebooks*
Richard Herrnstein & Charles A Murray's *The Bell Curve: Intelligence and Class Structure in American Life*
Eric Hoffer's *The True Believer: Thoughts on the Nature of Mass Movements*
Jane Jacobs's *The Death and Life of Great American Cities*
Robert Lucas's *Why Doesn't Capital Flow from Rich to Poor Countries?*
Jay Macleod's *Ain't No Makin' It: Aspirations and Attainment in a Low Income Neighborhood*
Elaine May's *Homeward Bound: American Families in the Cold War Era*
Douglas McGregor's *The Human Side of Enterprise*
C. Wright Mills's *The Sociological Imagination*

Thomas Piketty's *Capital in the Twenty-First Century*
Robert D. Putman's *Bowling Alone*
David Riesman's *The Lonely Crowd: A Study of the Changing American Character*
Edward Said's *Orientalism*
Joan Wallach Scott's *Gender and the Politics of History*
Theda Skocpol's *States and Social Revolutions*
Max Weber's *The Protestant Ethic and the Spirit of Capitalism*

THEOLOGY

Augustine's *Confessions*
Benedict's *Rule of St Benedict*
Gustavo Gutiérrez's *A Theology of Liberation*
Carole Hillenbrand's *The Crusades: Islamic Perspectives*
David Hume's *Dialogues Concerning Natural Religion*
Immanuel Kant's *Religion within the Boundaries of Mere Reason*
Ernst Kantorowicz's *The King's Two Bodies: A Study in Medieval Political Theology*
Søren Kierkegaard's *The Sickness Unto Death*
C. S. Lewis's *The Abolition of Man*
Saba Mahmood's *The Politics of Piety: The Islamic Revival and the Feminist Subject*
Baruch Spinoza's *Ethics*
Keith Thomas's *Religion and the Decline of Magic*

Macat Disciplines

Access the greatest ideas and thinkers across entire disciplines, including

FEMINISM, GENDER AND QUEER STUDIES

Simone De Beauvoir's
The Second Sex

Michel Foucault's
History of Sexuality

Betty Friedan's
The Feminine Mystique

Saba Mahmood's
*The Politics of Piety:
The Islamic Revival and
the Feminist Subject*

Joan Wallach Scott's
*Gender and the
Politics of History*

Mary Wollstonecraft's
*A Vindication of the
Rights of Woman*

Virginia Woolf's
A Room of One's Own

Judith Butler's
Gender Trouble

Macat analyses are available from all good bookshops and libraries.

Access hundreds of analyses through one, multimedia tool.

Join free for one month **library.macat.com**

Macat Disciplines

Access the greatest ideas and thinkers across entire disciplines, including

INEQUALITY

Ha-Joon Chang's, *Kicking Away the Ladder*

David Graeber's, *Debt: The First 5000 Years*

Robert E. Lucas's, *Why Doesn't Capital Flow from Rich To Poor Countries?*

Thomas Piketty's, *Capital in the Twenty-First Century*

Amartya Sen's, *Inequality Re-Examined*

Mahbub Ul Haq's, *Reflections on Human Development*

Macat analyses are available from all good bookshops and libraries.

Access hundreds of analyses through one, multimedia tool.
Join free for one month **library.macat.com**

Macat Disciplines

*Access the greatest ideas and thinkers
across entire disciplines, including*

CRIMINOLOGY

Michelle Alexander's
*The New Jim Crow:
Mass Incarceration in the
Age of Colorblindness*

**Michael R. Gottfredson
& Travis Hirschi's**
A General Theory of Crime

Elizabeth Loftus's
Eyewitness Testimony

**Richard Herrnstein
& Charles A. Murray's**
*The Bell Curve: Intelligence and
Class Structure in American Life*

Jay Macleod's
*Ain't No Makin' It:
Aspirations and Attainment in a
Low-Income Neighborhood*

Philip Zimbardo's
The Lucifer Effect

Macat Disciplines

*Access the greatest ideas and thinkers
across entire disciplines, including*

Postcolonial Studies

Roland Barthes's *Mythologies*
Frantz Fanon's *Black Skin, White Masks*
Homi K. Bhabha's *The Location of Culture*
Gustavo Gutiérrez's *A Theology of Liberation*
Edward Said's *Orientalism*
Gayatri Chakravorty Spivak's *Can the Subaltern Speak?*

Macat Disciplines

Access the greatest ideas and thinkers across entire disciplines, including

GLOBALIZATION

Arjun Appadurai's, *Modernity at Large: Cultural Dimensions of Globalisation*

James Ferguson's, *The Anti-Politics Machine*

Geert Hofstede's, *Culture's Consequences*

Amartya Sen's, *Development as Freedom*

Macat analyses are available from all good bookshops and libraries.

Access hundreds of analyses through one, multimedia tool.
Join free for one month **library.macat.com**

Macat Disciplines

Access the greatest ideas and thinkers across entire disciplines, including

THE FUTURE OF DEMOCRACY

Robert A. Dahl's, *Democracy and Its Critics*
Robert A. Dahl's, *Who Governs?*
Alexis De Toqueville's, *Democracy in America*
Niccolò Machiavelli's, *The Prince*
John Stuart Mill's, *On Liberty*
Robert D. Putnam's, *Bowling Alone*
Jean-Jacques Rousseau's, *The Social Contract*
Henry David Thoreau's, *Civil Disobedience*

Macat analyses are available from all good bookshops and libraries.

Access hundreds of analyses through one, multimedia tool.
Join free for one month **library.macat.com**

Macat Disciplines

*Access the greatest ideas and thinkers
across entire disciplines, including*

TOTALITARIANISM

Sheila Fitzpatrick's, *Everyday Stalinism*
Ian Kershaw's, *The "Hitler Myth"*
Timothy Snyder's, *Bloodlands*

Macat Disciplines

Access the greatest ideas and thinkers across entire disciplines, including

MAN AND THE ENVIRONMENT

The Brundtland Report's, *Our Common Future*
Rachel Carson's, *Silent Spring*
James Lovelock's, *Gaia: A New Look at Life on Earth*
Mathis Wackernagel & William Rees's, *Our Ecological Footprint*

Macat analyses are available from all good bookshops and libraries.

Access hundreds of analyses through one, multimedia tool.
Join free for one month **library.macat.com**

Macat Pairs

ARE WE FUNDAMENTALLY GOOD - OR BAD?

Steven Pinker's
The Better Angels of Our Nature

Stephen Pinker's gloriously optimistic 2011 book argues that, despite humanity's biological tendency toward violence, we are, in fact, less violent today than ever before. To prove his case, Pinker lays out pages of detailed statistical evidence. For him, much of the credit for the decline goes to the eighteenth-century Enlightenment movement, whose ideas of liberty, tolerance, and respect for the value of human life filtered down through society and affected how people thought. That psychological change led to behavioral change—and overall we became more peaceful. Critics countered that humanity could never overcome the biological urge toward violence; others argued that Pinker's statistics were flawed.

Philip Zimbardo's
The Lucifer Effect

Some psychologists believe those who commit cruelty are innately evil. Zimbardo disagrees. In *The Lucifer Effect*, he argues that sometimes good people do evil things simply because of the situations they find themselves in, citing many historical examples to illustrate his point. Zimbardo details his 1971 Stanford prison experiment, where ordinary volunteers playing guards in a mock prison rapidly became abusive. But he also describes the tortures committed by US army personnel in Iraq's Abu Ghraib prison in 2003—and how he himself testified in defence of one of those guards. committed by US army personnel in Iraq's Abu Ghraib prison in 2003—and how he himself testified in defence of one of those guards.

Printed in the United States
by Baker & Taylor Publisher Services